EX LIBRIS

PHOTOGRAPHY
A CRASH
COURSE

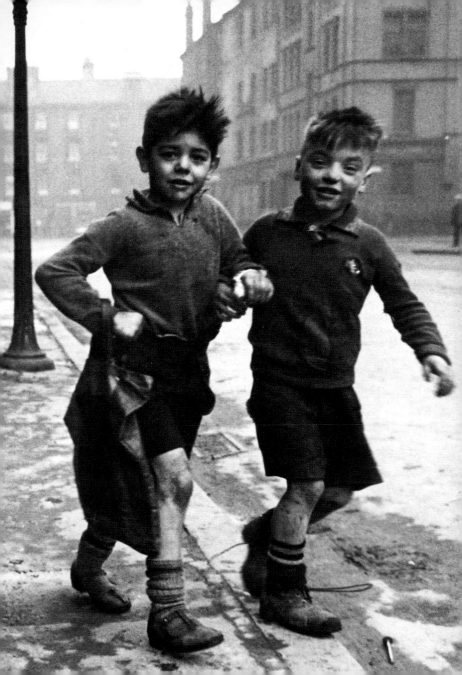

PHOTOGRAPHY
A CRASH
COURSE
DAVE YORATH

WATSON-GUPTILL
PUBLICATIONS
New York

First published in the United States in 2000
by Watson-Guptill Publications, a division of
BPI Communications, Inc., 770 Broadway,
New York, NY 10003

www.watsonguptill.com

Library of Congress
Catalog Card Number: 00-104279

ISBN 0-8230-0986-6

*This book was conceived, designed,
and produced by*
THE IVY PRESS LIMITED
The Old Candlemakers, West Street
Lewes, East Sussex, BN7 2NZ, England

Art Director: PETER BRIDGEWATER
Editorial Director: SOPHIE COLLINS
Designer: JANE LANAWAY
Editor: GRAPEVINE PUBLISHING SERVICES
DTP Designer: CHRIS LANAWAY
Illustrations: IVAN HISSEY
Picture Researcher: VANESSA FLETCHER

Printed and bound in Hong Kong by
Hong Kong Graphic and Printing Ltd.

1 2 3 4 5 6 7 8 9 / 08 07 06 05 04 03 02 01 00
This book is typeset in Bauer Bodoni 8/11.

DEDICATION

In memory of
Andre Krzowski
"as promised"

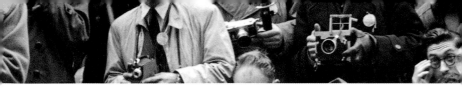

Contents

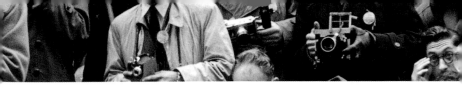

Introduction

Not everyone paints. Not everyone sculpts in bronze or marble, writes symphonies, or pens a great work of literature. Such pursuits belong to the realm of "high art," where a rare talent intercedes in the process of creation.

These high arts, underpinned by 2000 years of history and criticism, seem distant, authoritative, and faintly magical. But we can all participate in the production and consumption of photographs; the medium permeates every aspect of our lives, surrounding and cocooning us in a seemingly endless array of advertising, editorial, domestic, commercial, and creative images. We all do it or have it done to us.

This ubiquity, bound up with the apparent simplicity of the photographic process, has triggered a sort of multiple personality disorder: photography seems unsure of

David Bailey contemplates his oeuvre.

what it is, feeling overawed and not a little abashed in the elevated company of the traditional, "fine" arts. Much of this identity crisis has arisen from the notion that photography is largely driven by technique, or, more specifically, by equipment, since the photographer—the "author"—is largely invisible. When we look at a photograph, we tend to look past its surface to the original subject. With painting and sculpture, their physical properties cause us to reflect upon the

The first three images in Rosy Martin's series "Memento Mori Manifest."

skill, dexterity, and sometimes genius of the artist, but with the photograph, our gaze rarely halts at its surface to consider the intentions and message of the practitioner.

How this course works

Each double-page spread is devoted to a photographic style, a photographer, or a group of photographers with something in common, and the story proceeds more or less chronologically. On each spread there are some regular features. It won't take you long to figure them out, but check the boxes on pages 8–11 for more information.

And so, to arrest our attention, photographers have attempted to emphasize the unique properties of their medium by identifying certain elements of the photographic process, thereby hoping to elevate it to the lofty realms of fine art.

What is surely most important is what the photographer is saying with the work, what motivates, intrigues, angers, amuses, moves, and fascinates

the "I" behind the lens. What makes a good photograph? On one side, there are those who support the notion that photography records the "real"; on the other are those who see it as a vehicle for self-expression.

As photography moves into the 21st century, with its concomitant advances in technology, we shall also see how historical perceptions of what photography is, or was, are breaking down and being reexamined. Photography has relied for its authority on an innate belief that it is "real," or worse still, "true." We put our trust in the materials and methods followed by the documentary photographer and we therefore have faith in the work. It is the belief in this accuracy that has given photography its veneer of

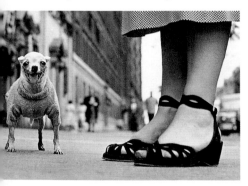

Dog and shoes by Elliott Erwitt, a specialist in quirky canines.

respectability, its bastion against the voyeuristic pervert brigade, and although history has offered countless examples of images that have been manipulated, it is only now, with the ever-increasing use of digital imagery, that it is slowly beginning to dawn on people that while the camera may never lie, it often has its fingers crossed. In this book we shall explore photography's attempts

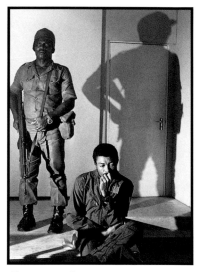

Abbas captures a decisive moment after a coup in Ghana, 1982.

Gossip
An occasional item about the scandals and vicissitudes of the photographer's secret life.

Timeline
More of a contextual chronology than a timeline, because photographers and movements are constantly overlapping. A selected list of major events happening at the time each was popular, to illuminate the world they were photographing. For example, Queen Victoria was learning how to use the telephone at the same time as Muybridge was photographing galloping horses, and sliced bread was invented around the time Edward Weston and Ansel Adams started their influential Group f/64.

to carve out a true niche for itself, and examine some of the many examples—some sincere, some ludicrous—that attempt to define the nature of the photographic practice. This is inevitably a personal overview, and to all those whose heroes and heroines have been omitted—write your own book!

DAVE YORATH

c. 65,000 B.C. It's the beginning of an Ice Age and *Homo sapiens* begins to displace *Homo erectus*.

c. 21,000 B.C. An unknown artist paints a very attractive bison on his cave wall in Altamira, Spain. It's rediscovered in 1878.

c. 5000 B.C. Mummification techniques are in use in Chile.

65,000 B.C.~A.D. 1500

Now You See It, Now You Don't
The inverted image

Box of tricks

To make a simple pinhole camera, roll a 15-inch square of thin black oaktag into a tube. Tape up the join. Cut circles of black oaktag to form a base and a lid. Tape the base on permanently, but allow the lid to be easily removed. Cut a 1-inch square hole midway up the tube and tape over it a piece of tinfoil with a pinhole pushed through. Use a piece of black duct tape for a shutter. Under redlight conditions, bend photographic paper inside the tube opposite the pinhole. Aim the camera at the subject, remove the duct tape, count to five, and replace the tape. Develop the paper in photographic chemicals. If the image is too light, extend the exposure time. If it's too dark, reduce the exposure time. It's a piece of cake!

You're in your cave. After a memorable lunch of roots, berries, and unidentifiable animal parts, you've settled back to mull over your life as a hunter-gatherer. Shafts of light pierce the thick vegetation that protects you from the harsh, sun-bleached outside world to dapple the wall of the cave. Life is good. Slowly (remember, you're not too bright), you realize that the light on the wall is forming a familiar picture. You begin to make out an upside-down version of the world beyond your cave. This is strange. You don't really have the scientific wherewithal to understand this, and so, as a woolly mammoth or something equally overendowed in the fang department saunters past on your makeshift screen, you're off quick as a flash into the farthest corner for some serious gibbering.

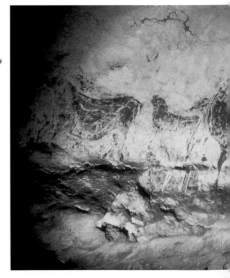

What you've just seen (although, let's face it, it's wasted on you) is one of the basic principles of the photographic process in action. Light, when reflected from an object, can be focused by a simple lens or pinhole and will form an inverted image within a dark, enclosed space.

c. 2575-2465 B.C. The Egyptians build the pyramids at Giza. However, some claim they were left by an unknown earlier civilization and just adopted by the Egyptians. Others say they were built by space aliens.

A.D. 105 The Chinese invent paper, so artists don't need to draw on walls any more.

c. 1000 The Hohokam people of Arizona develop a technique for etching shells with acid. And why not?

AMAZING DISCOVERIES

This property of light was later observed and recorded many times. One of the first to note it, and to correctly identify the principles behind it, was a Chinese scholar from the 5th century B.C. called Mo Ti, and 200 years later Aristotle refers to the same phenomenon in his writings. In the 10th century the Arabian scholar Ibn Al-Haitham (known also as Ibn Alhazen) discovered that when the hole that transmits the light is relatively large, each ray spreads out and the image is therefore slightly fuzzy. If the size of the hole is decreased, the image formed is sharper and more discernible. So, while our cave-dweller friend reacted to what he saw by going into shock and maybe starting a new

After posing for 48 solid hours, Aristotle is dreaming of a faster means of representation.

religion, over the following centuries scholars gained an incremental knowledge of the properties of light that by the Renaissance had resulted in the first identifiable application of photography, the camera obscura (literally, "the dark room").

Wacky pinholes

The pinhole camera has undergone something of a popular revival in recent years. It is one of the simplest and, in some ways, purest forms of photography. Jo Spence (see page 120) used a converted rubber boot to create her pinhole, and others have chosen equally outlandish devices. From converting garbage cans to secreting a 110 film cartridge in their mouths with their lips acting as a shutter, a whole new generation of photographers have rediscovered exotic ways of creating the image (and looking stupid to boot).

Early home entertainment system: a Lascaux cave painting of 15,000 B.C. showing a black cow.

1508–18 Leonardo da Vinci writes his notebooks of scientific observation. Among his discoveries: "The function of muscle is to pull and not to push, except in the case of the genitals and the tongue."

1519 Ferdinand Magellan begins the first circumnavigation of the globe. He's killed in the Philippines in 1521 but the original ship gets back to Spain the following year.

1605 In London, Guy Fawkes tries to blow up the British Houses of Parliament; children ever since have been pleased to remember him on Bonfire Night.

1500~1800s
In a Dark Room
The camera obscura

Della Porta and the artists of the Renaissance lived in a time of great change. Science began to emerge from the murky depths of alchemy and the occult, and the various elements and driving forces that would eventually coalesce to produce an identifiable form of photography were gradually emerging (although this didn't help della Porta much: he was tried for sorcery after a disastrous audience reaction to an early public demonstration of his room-sized camera obscura).

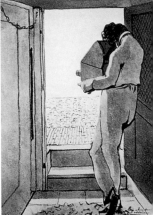

Artist discovers that the portable camera obscura leaves no hand free for drawing.

Box of tricks

A simple glass lens is pretty much like a magnifying glass, the sort you used to scorch the skin off the back of your friend's hand when you were a kid. As light passes through a simple lens, it is concentrated and focused into a point.

By the mid-1500s, the pinhole had largely been replaced by a simple glass lens, which gave a sharper, clearer image—the Venetian Danielo Barbaro wrote of the advantages of this new development in the 1560s. So with this, we have the physical components in place; it just remains for the chemistry to be worked out. Unfortunately, this takes a little while longer.

In 1727 the German scientist *Johann Schulze* (1701–67) published a discovery: that a precipitate of chalk in nitric acid turned purple when left in strong sunlight. Further investigation identified the silver salts in this mixture as the key ingredients in this process. Johann is one step away here from inventing photography, but not foreseeing any use for this process, discovers phosphorus instead—leaving to posterity the box of matches and a major component of napalm.

Arty facts

Initially used by astronomers and architects, the camera obscura, in the form of a portable tent or box, rapidly became a valuable tool for artists, enabling them to record details of landscape and perspective with accuracy. In his notebooks, Leonardo da Vinci (1492–1519) predicted the growing use of the camera; and in 1568 the Venetian architect Giovanni Battista della Porta (1538–1615) recommended its use to the artists of the day. From the 16th century to the early Victorian period, the camera obscura and its later more portable version, the camera lucida, became an essential tool for many artists, including Canaletto, Reynolds, Ruskin, and, significantly, Fox Talbot.

1634 Rembrandt marries Saskia van Uylenburgh, the cousin of a famous art dealer, but she dies in childbirth eight years later.

1756 The nawab of Bengal locks 146 British captives in the Black Hole of Calcutta, a small underground room with inadequate ventilation. All but 23 die.

1793 Marie Antoinette says "Let them eat cake!" and loses her head as a result.

THE NEXT STEPS

Other scientists followed in Schulze's footsteps. A decade later, *Jean* HELOT (1703–89) used silver nitrate to create a form of "invisible ink" that appeared when exposed to sunlight, thus gladdening the hearts of schoolkids everywhere, not to mention, of course, the KGB. *Carl* STEELE (1748–1805), in the latter half of the 18th century, discovered not only that a chloride of silver was blackened by sunlight but also that ammonia could be used as a fixing agent. Close, but lacking in the cigar department.

But the forces of history are massing. Developments in technology conspire with the artist's constant search for new materials and forms of expression. There is now an imperative, driven by the growing need for the mechanical reproduction of images within the burgeoning industries of the late 18th century, the popularity of quasi-photographic images such as the silhouette, and the new breed of artist/industrialist who wished (although few would admit to it) to improve upon the camera obscura and create images direct from nature.

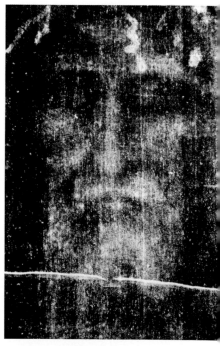

The camera obscura, consisting of a lightproof box with a pinhole aperture.

Shrouded in mystery

The Turin Shroud, a burial cloth impregnated with the image of a man (supposedly Jesus Christ) has excited mystics, academics, and Christians alike, and has spawned heated debate, as well as much literature, speculating on its provenance. Among the more interesting theories is that of South African Professor Nicholas Allen, who experimented with techniques that would have been available at the time of Leonardo da Vinci, and postulated that the image visible on the Turin Shroud could be a photographic negative created by a pinhole camera.

The enigmatic face of the Turin Shroud: who was he really?

1803 Thomas Bruce, Earl of Elgin, starts shipping back to England parts of the sculptured frieze on the Parthenon, which dates back to 438 B.C.

1816 Sir William Herschel (John's brother) is knighted for his work, including discovering Uranus and cataloging more than 800 double stars and 2,500 nebulae.

1830 John James Audubon publishes the first edition of *Birds of America*, with his meticulous aquatints of birds in their natural habitats.

1800~1870s

Looking for a Fix

Origins of modern photography

It was left to Thomas WEDGWOOD (1771–1805), the son of the famous potter, Josiah Wedgwood, to bring together the various strands that would lead to the development of a "true" photographic process at the beginning of the 19th century.

Thomas was familiar with the camera obscura, which was used extensively to produce accurate drawings for the tableware decorations required by the aristocratic Wedgwood clientele; he was also aware of Schulze's experiments regarding the properties of silver salts; and he was eager to find a method of mechanically recording the gardens, landscapes, and stately homes commissioned for imperial crockery by the Russian monarchy. By placing an object on sensitized paper and exposing it to sunlight, he was able

Box of tricks

When a ray of light hits a photographic emulsion, it creates a reaction in particles of silver salts that, when developed, turn into black metallic silver. So this explains why the light areas of the subject become dark areas on the negative, and also why film is expensive. When prints are made, the light/dark process reverses, displaying the tones of the original subject (give or take).

IN THE FRAME

In his boundless enthusiasm for invention, Sir John Herschel developed yet another technique for the production of photographic images. From his observations that the iron salt compound known as Prussian Blue was sensitive to sunlight, he created the Cyanotype, widely known in the engineering world as a "blueprint." One of the first to see the possibilities of this process was the botanist **Anna Atkins** *(1799–1871). She used the Cyanotype to document specimens from her burgeoning plant collection and published this work under the title* British Algae: Cyanotype Impressions *in 1843. These "shadowgraphs," as Atkins titled them, were arguably the first true published photographs.*

to create photographic images, but without any means of fixing the image and making it insensitive to light, he was reduced to the utmost frustration of viewing it by candlelight and watching it fade quickly to black.

1842 The British win Hong Kong from the Chinese and it becomes a convenient port for the storage and distribution of drugs such as opium.

1855 Miller's Beer is first brewed in Milwaukee by Frederick Miller.

1876 Custer finds himself in a lot of trouble when he tangles with Sioux-Cheyenne forces at Little Big Horn.

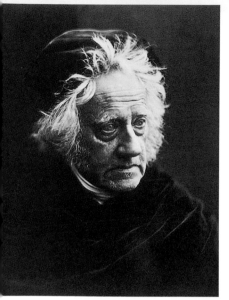

Sir John Frederick William Herschel, by Julia Margaret Cameron (1867).

with techniques that, while not becoming established as mainstream photographic forms, certainly occupy a significant staging point along the way.

In 1839, the astronomer *Sir John Herschel* (1792–1871), having learned of the work of Fox Talbot and Daguerre, began "arresting" the further action of light on silver salts. Drawing on observations he had made 20 years before, when he had noted that hyposulfite of soda dissolved silver salts, he successfully "fixed" the image —and in doing so he created the process that is still widely used for the production of photographic images. Herschel is also notable for coining the terms "positive" and "negative," and for bringing the word "photography" into common usage.

Mungo Ponton lives up to his nation's reputation for canniness by inventing a cheaper fixing system.

As we shall see, three main pioneers, Fox Talbot (*see page 24*), Niépce (*see page 18*), and Daguerre (*see page 20*), created the root mechanisms from which stemmed the practice of photography as we know it today. Fox Talbot's picture of a window in Lacock Abbey is the earliest extant camera negative. But many others— scientists, artists, and the well-to-do of Victorian society —experimented

And let us not forget the memorably named Mungo Ponton, a Scotsman who evolved a system that used potassium bichromate, which was much less expensive than the silver-based solutions in use by his contemporaries.

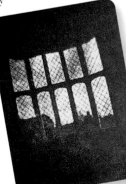

Fox Talbot's "Lattice Window, Lacock Abbey," 1835.

1820 A Greek peasant named Yorgos moves a boulder and finds an underground chamber containing the armless Venus de Milo, which dates from the 2nd century.

1821 Napoleon dies on the island of St. Helena and it takes 7 weeks for the news to travel back to Paris.

1823 British inventor Francis Romalds invents an electric telegraph. He offers it to the Admiralty but they don't think it will ever catch on.

1820s

A Lasting Impression
Niépce and heliography

Joseph Nicéphore Niépce's shadowy image of "Rooftops, Graz," 1826.

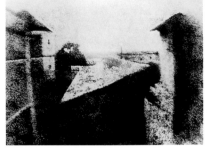

The Frenchman Joseph Nicéphore NIÉPCE (1765–1833) was an inveterate inventor, patenting many devices and discoveries—among them a primitive form of bicycle and a boat engine powered by exploding powder (whatever happened to that?). More significantly, in the 1820s, he began devising a coated metal sheet to replace the large stone plates used in the new field of lithographic printing. And because, as he himself admitted, he was frankly lousy at drawing, he wanted, like Wedgwood, to find a way of introducing the image to the plate mechanically.

Niépce and his explosive boat.

He followed a familiar route at first, using silver salts and hitting the same problems when it came to fixing the image. He was more successful when he used bitumen of Judea, a form of asphalt that hardens when exposed to light. Using oiled copies of engravings to give them transparency as negatives, he was able to reproduce the originals with reasonable accuracy. History doesn't record the exact moment when he thought, "I wonder what would happen if I whack one of these plates in my camera obscura and point it out of my bedroom window for a while?" but eight hours later, having dissolved away the unexposed bitumen with a solvent, Niépce had himself the world's first photograph. He had managed to get the name wrong and called it a "heliograph," but still, it was close.

DEVELOPING THE PROCESS

This first image, from the room in Graz, near Niépce's home town of Chalon-sur-Saône, would probably not win any awards in the local camera club annual prize-giving, because the long exposure time had softened the detail in the highlights and shadows and the shiny metallic plate had made viewing difficult.

1824 John Cadbury experiments with grinding cocoa beans in a mortar and pestle and billions of chocaholics still bless his name.

1828 London Zoo opens to the public, and has on display the first hippopotamus to be seen in Europe since the Romans showed one at the Colosseum.

1829 Siamese twins Chang and Eng, joined at the chest from birth, attract worldwide attention. They marry two North Carolina women and sire 22 children between them.

Later, Niépce would work with glass-coated plates, making his subsequent images far more subtle and distinct; but it is still this first hazy, fuzzy scene of rooftops and trees that forms a blotchy but major milestone in the long inexorable march of photography.

Unlike Schulze, who goes down in photographic history as the man who invented purple liquid, Niépce was at least aware of the fact that he'd got something here but was unsure of the direction that

Joseph Nicéphore Niépce also invented a primitive bicycle, the celeripede.

Moving pictures
The truly idle could buy a camera obscura built into a sedan chair. A rotating turret on the top allowed the passenger to sit in comfort and view their surroundings with impunity. We can only imagine the thoughts of the passing proletariat as they viewed this strange spectacle.

this startling invention could take. Seeking ways to capitalize on his discovery, he got together with Louis Daguerre (*see page 20*) who, he believed in all innocence, was working toward the same end.

Niépce's "Still Life with Bottles and Glasses," 1826.

Not my kind of a picnic—there's no food.

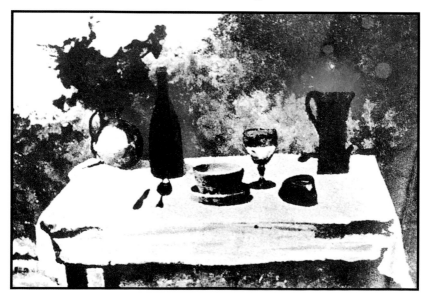

PHOTOGRAPHY ~ A CRASH COURSE

1830 Victor Hugo's *Hernani* opens at the Comédie Française in Paris.

1831 Slaves account for a third of the population of the U.S.

1833 British inventor John Matthews comes up with the soda fountain and sells fizzy water to New Yorkers.

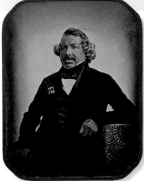

1829~1839
The French Concoction
Daguerreotypes and Dioramas

In the "chien-mange-chien" world of early French photography inventors, Louis-Jacques-Mandé DAGUERRE (1757–1851) has to be seen as leader of the pack. When Niépce first discussed his work with Daguerre, Daguerre's main claim to fame was as a showman, co-owner of the Diorama, and the possessor of an ego of biblical proportions.

Portrait of Daguerre looking mildly pompous. Taken in 1844 by Sabatier-Blot.

The sitters in this 1850 daguerreotype seem rather wary of the process.

The Diorama was a vast theatrical exhibition of scenic paintings made with the camera obscura, whereby lighting effects created the illusions of movement and the passing of time. This use of the camera obscura eventually led Daguerre to explore the possibilities of a photographic process that used copper plates coated with silver iodide. The resulting images were very successful in terms of detail and permanency, but they were "one-off" pictures that could only be seen from a certain angle.

Panorama boy
Daguerre began his career as an apprentice painting panoramas—these gigantic pictures of battles and landscapes were hugely popular in Europe at the beginning of the 19th century. These were either a 360-degree view with the spectator standing in the center and swiveling around, or a section of a scroll passing in front of a stationary spectator, and they were often found in traveling exhibitions.

Daguerre evidently talked Niépce out of publishing his work, and instead cajoled him into signing up to a ten-year joint development contract in December 1829. History can see Niépce as having a rather large hole in his marble bag for agreeing to this, but from the perspective of the time, with the possibilities of photography yet to be realized, it serves as an indication of his eagerness to develop the idea.

Daguerre's true colors were revealed after Niépce's death in 1833, when he persuaded

Box of tricks

Daguerreotypes were made by coating a copper plate with polished silver. This was held over a solution of iodine, sensitizing the silver. After exposure, the plate was held over a box containing heated mercury—don't try this at home—which made the image visible, and then immersed in a salt solution for permanency.

Niépce's son Isidore (1795–1868) to sign an agreement stating that the invention was entirely Daguerre's. And it was Daguerre who took the lion's share of the outright purchase of the discovery, which was made by the French government largely to prevent Daguerre from selling the process to the highest bidder (*see page 22*). Daguerre sought personal fame and fortune from his invention— not in itself a bad thing, but throughout there is the sense that he was not averse to a bit of shady dealing to further his ambitions and his place in posterity. There's a bit of a clue in the title he gave to his process.

Daguerre threw himself into the manufacture and marketing of his cameras and plates, and by the time of his death in 1851, he had received the Legion d'Honneur and was living the life of the French landed gentry.

Allegedly the first news picture of a thief literally having his collar felt. "Arrest in France," 1847.

IN THE FRAME

Early images were produced as paper negatives or direct positives, making high-quality reproductions unattainable. Attempts to sensitize glass plates for negatives had proved problematic, as the light-sensitive coating would not stick. In 1848 **Claude Niépce de Saint-Victor** *(1805–70) perfected the first glass plates, using egg white to hold the silver salts, although the emulsion reacted to light very slowly and could only be used for long exposures. It wasn't until the early 1870s, when* **Dr. Richard Maddox** *(1816–1902) used gelatin to hold the silver salts, and* **John Carbutt** *(1832–1905) got thin strips of celluloid on which to coat this new emulsion, that photographic film took on its familiar appearance.*

1837 Five-sixths of the area of Manhattan is covered with farms and gardens, and only a sixth is built up.

1837 Charles Dickens' Oliver Twist speaks for a massive underclass when he says "Please, sir, I want some more."

1838 The Boers kill more than 3,000 Zulus at the Battle of Blood River.

1837~1840

Not Drowning, Only Waving
Hippolyte Bayard and forgotten others

Bayard puttering in his lab.

Lost amid all the furore surrounding the promotion of the daguerreotype and now providing little more than a footnote in history, there were at the time other pioneers, driven by the same imperatives, who were experimenting with photographic processes.

While the negotiations between Daguerre and the French government were at a critical stage, up pops a lowly office worker at one of the French government ministries by the name of *Hippolyte BAYARD* (1801–87) who, in July 1839, exhibits a whole fistful of images produced by using yet another variation of the photographic technique. Bayard took paper coated with silver chloride, exposed it to the light, then recoated it with potassium iodide, inserted it into the camera, bleached the result—et voilà!—individual, paper-positive images, which in some ways were more effective than the daguerreotypes, since they could be easily viewed. François Arago, the member of the French Chamber of Deputies charged with bringing the discoveries of Daguerre and Niépce under the control of the government, was not pleased; the last thing he needed was any muddying of the waters. Although Bayard was given a relatively small sum of money to continue his work, he was effectively sidelined and shunted into obscurity.

Ironically, however, he has found his place in the iconography of the photograph, having produced what is arguably the first use of the image for political purposes. Realizing that he had been conned, Bayard produced a "Self-Portrait as a Drowned Man" in 1840, on the reverse of which he wrote, "The body

We can safely assume that Hippolyte Bayard had a hand in this image of 1842.

1839 Berlioz's *Romeo and Juliet* premieres at the Paris Conservatoire.

1839 The rules of rugby are established by a Cambridge student called, appropriately, Arthur Fell.

1840 In the U.K. the first adhesive postage stamp, the Penny Black, goes on sale. It is printed by Jacob Perkins, who has also developed the technology for printing banknotes.

you see before you is that of Monsieur Bayard […] The Academy [of which Arago was a member], the King and all who have seen his pictures admired them, just as you do. Admiration brought him prestige, but not a sou. The Government, which gave M. Daguerre so much, said it could do nothing for M. Bayard at all, and the wretch drowned himself." It's safe to say he was only pretending, and he lived on to continue producing photographs using both his own techniques and—we can conjecture, grudgingly—those of his rivals.

Poetically composed, Hippolyte Bayard's "Self-Portrait as a Drowned Man" (1840) is believed to be the first fictional image in photographic history.

IN THE FRAME

As news of the discovery of these new processes and the potential financial gains leaked out into the world at large, many other "inventors" crawled out of the woodwork. Most of these consisted of the "I thought of it first" variety, unsupported by anything resembling evidence. It was a bit like saying: "I first invented the microchip but unfortunately the dog ate my notes." A few of these stand more than a cursory investigation. **Hercules Florence** claimed he first produced images using a process he termed "photographie" in 1832, and the Norwegian **Hans Winther** purported to have made direct positive images as early as 1826. In the meantime, however, a gentleman by the name of **William Henry Fox Talbot**, a middle-class Englishman with time on his hands, had been quietly getting on with inventing a process all on his own (see page 24).

1830 Joseph Smith publishes the Book of Mormon; he says he translated it with the help of the hieroglyphics on some tablets at Palmyra, which he heard about from an angel called Moroni.

1831 Leopold I becomes the king of Belgium a year after the country declares its independence from Holland.

1832 French caricaturist Honoré Daumier is jailed for six months for portraying King Louis Philippe as a Gargantua gorging himself on the earnings of the working classes.

1830s
The Pencil of Nature
Photogenic drawing

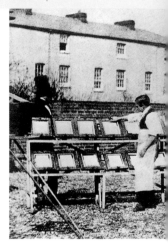

William Henry Fox TALBOT (1800–77) was what the British would have called a "toff." He inherited the stately Lacock Abbey and was a Fellow of the Royal Society. And, like Wedgwood and Niépce, he was yet another person who couldn't draw to save his life. He discovered the negative/positive method of photography at the same time as the French and paved the way for generations of snooty art history professors who still think that photography is for those people who don't know their Conté crayons from their elbow patches.

He notes in his journal of October 1833 that while amusing himself on the lovely shores of Lake Como, "taking sketches with Wollaston's camera obscura, or rather, I should say, attempting to take them: but without the smallest amount of success [this is a man who can't even trace a landscape!]. I then thought of trying again a method which I had tried many years before. The method was, to take a camera obscura and to throw the image of the objects on a piece of paper in its focus—fairy pictures, creations of a moment, and destined as rapidly to fade away. It was during these thoughts that the idea occurred to me—how charming it would be if it were possible to cause these natural images to imprint themselves durably, and remain fixed upon the paper."

Using paper coated with silver chloride, Fox Talbot "fixed" the resulting images with a strong salt solution, giving the pictures a semipermanency. One of his original experiments, dating from 1835, survives today in the Science Museum, in London, and shows the latticed window in one of the corridors of Lacock Abbey.

Box of tricks

The "camera lucida" was designed in 1807 by the English scientist William Wollaston (1766–1828). This lightweight equipment used a prism to project the view onto a sheet of drawing paper. A viewer next to the prism allowed the user to see both subject and paper simultaneously so that by tracing the virtual image an accurate drawing could be made. This was, of course, cheating.

1834 Six Dorset farm workers, known as the Tolpuddle Martyrs, are sentenced to deportation to Australia for swearing an oath to join a trade union.

1837 There is a mania for all things to do with fairies. Richard Dadd is painting them and Hans Christian Andersen publishes four new fairy tales a year.

1838 Kirkpatrick MacMillan of Dumfries, Scotland, invents the first true bicycle.

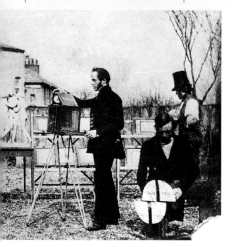

The pioneering Fox Talbot and friends, c. 1840, being photographed while photographing his studio. Must have been a bit drafty.

SPURRED BY COMPETITION

Fox Talbot worked away quietly on his experiments throughout the 1830s, and was therefore the Victorian equivalent of flabbergasted when he read of Daguerre's work in the *Literary Gazette* in January 1839. This galvanized him somewhat: within a week he was showing samples of his work to the Royal Institution in London, and before the end of the month he had not only written to the French authorities claiming he made his discovery before Daguerre, but also had his paper "Some Account of the Art of Photogenic Drawing, or the Process by which Natural Objects May be Made to Delineate Themselves without the Aid of the Artist's Pencil" read to the Royal Society.

Fox Talbot continued to refine his discovery, which he called the "calotype," and published the first book of photographic images, *The Pencil of Nature*, in 1844. He patented his processes and equipment, but in a gesture which would have been foreign to Daguerre, made them freely available to amateurs starting in 1851. This act of altruism is diluted somewhat by the fact that the only "amateurs" of the period who could afford the materials or time to indulge this new passion would mainly have been the emerging middle classes or the aristocracy.

Competitive types

In the 1840s it seems that the war between the daguerreotype and the calotype was being won by the French contender. A license to set up a studio using Daguerre's method cost an enormous $330, but the returns were correspondingly great—up to $99 a day. Meanwhile, a studio owned by Henry Collen using the calotype earned a little over $330 for the whole year.

"The Open Door," an undated photograph from *The Pencil of Nature*.

1843 A 17-foot statue of Lord Nelson is hauled to the top of Nelson's Column in Trafalgar Square in two pieces.

1844 J.M.W. Turner is one of the first artists to portray the new-fangled steamship and railroad in *Rain, Steam, Speed.*

1848 Karl Marx calls for workers of all countries to unite, in the *Communist Manifesto.*

1840~1850s

I Know a Lot about Art...
But I don't know what I like

Because they created a direct positive, Daguerre's images tended to be comparatively sharper in definition than those of Fox Talbot; Fox Talbot's method relied on a paper negative from the camera that was subsequently contacted onto fresh paper to produce a positive image, yielding a generally more fuzzy and impressionistic result. This divergence led to some early splits between the scientific and artistic community over the uses to which this new medium should be put.

The schism between the documentary and the metaphorical was embedded even as Niépce mopped up the surplus solvent from his first image. As one group of early photographers called for accuracy, sharpness, and faithfulness to the original, both physically and conceptually, an opposing faction believed that fine art and theatrical traditions should form the basis of any exploration of the possibilities of this new form.

This latter group were helped by the tendency of middle-class Victorians to get

Box of tricks

Oscar J. Rejlander dabbled with that Victorian love of spiritualism, using double exposure to create "Hard Times" in 1861. This doesn't rival the cheek of the "Cottingley Fairies," a set of images faked by two young cousins that fooled the cream of society in 1917.

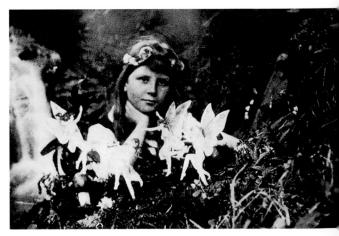

A fairy picture by Frances Griffiths and her cousin Elsie Wright in Cottingley.

1851 The firm Schweppe & Co. sells 177,737 dozen bottles of soft drinks in the U.K. this year; nearly 85,000 of them are drunk at the Great Exhibition.

1855 David Livingstone becomes the first European to see a great waterfall on the Zambezi River, and he calls it Victoria, after the British queen.

1859 While working in a timberyard in Mountain Ash in Glamorgan in southern Wales, John Lewis is hit by a rainstorm of falling fish.

IN THE FRAME

Oscar J. Rejlander (1813–75), a Swedish painter working in Wolverhampton, England, in the 1850s, created a vast allegorical work based on a painting by Raphael entitled The Two Ways of Life, *consisting of over 30 separate images that he seamlessly joined together. The six weeks he spent montaging this piece was given the ultimate validation when it was purchased by Queen Victoria for display in Prince Albert's study.*

Henry Peach Robinson (1830–1901), another painter-turned-photographer, used a similar montage technique to create "Fading Away" in 1858, an image not devoid of sentimentalism. He wrote the influential and controversial Pictorial Effect in Photography *(1869), based on traditional academic views of composition and structure, so probably didn't realize that the term "pictorial" would soon be seen as pejorative.*

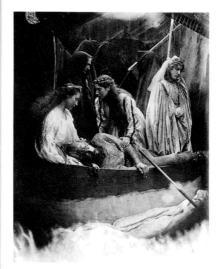

Julia Margaret Cameron, "Tennyson's Idylls of the King," c. 1875.

bored easily. Radio, television, and the cinema haven't been invented yet, so it had become customary to dress up for an evening and act out scenes from the classics: what could be more fun than to photograph these little tableaux?

In 1843, the painter *David Octavius HILL* (1802–70) worked with photographer *Robert ADAMSON* (1820–48) to produce a range of images, often using their friends suitably costumed up, based on the writings of Walter Scott.

Julia Margaret CAMERON (1815–79), probably best remembered for the series of portraits of her influential circle of friends, including Herschel and Tennyson, often succumbed to these costumed capers, drawing not only on religion and Renaissance art for her themes, but also that Arthurian legend stuff so favored by the Pre-Raphaelites.

The Pre-Raphs

The Pre-Raphaelite Brotherhood was a young, radical, and often deeply silly group of artists that broke away from the strictures of the Royal Academy of Arts in 1848. The rules of Art at the time were to adopt the techniques of the old masters and to use a lot of brown paint. The Pre-Raphaelites William Holman Hunt, John Everett Millais, and Dante Gabriel Rossetti wanted to paint direct from nature, with "objectivity" and "truthfulness," harking back to a time before, well, Raphael.

1851 Although a "Frankenstein" is defined as any creation that destroys its creator, we are assured that her monster is not responsible for the death of Mary Shelley this year.

1853 The world's largest tree is discovered in California and called the *Wellingtonia gigantea*.

1854 Stephen C. Foster writes the popular song "Jeanie with the Light Brown Hair."

1850s

Wonderful Things and Faraway Places
The Victorian explorer

It no longer seems odd that folks spend their vacations staring through the viewfinder of a camcorder, as if real life is somehow less valid. We all double-check to see that the camera's with the passports and sunblock before sealing the suitcase. But we'd no doubt think twice if taking those vacation shots meant toting the equivalent of a covered wagon, loaded with darkroom, glass plates, chemistry lab, and weighty wooden camera into the tropics.

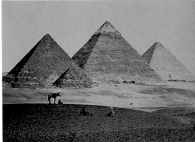

The beginnings of the tourist industry: the Pyramids of Giza by Francis Frith (1858).

B y the 1850s photographers in Europe and North America were caught up in the fervor for exploration, "discovering" new lands and old antiquities. Pictures of the lands of classical myth and legend, Italy, Greece, the Middle East, and especially Egypt, were highly valued by an

Part of a cumbersome English wet-plate camera of 1856.

informed and hungry audience. Although photographers had made these travels prior to the 1850s, the processes available to them didn't allow them to meet the needs of this growing market. The daguerreotype didn't lend itself to mass production and Fox Talbot's calotype suffered from its lack of sharp detail.

Two separate technical developments were to help. Until the 1840s most cameras used a simple lens, like that of a magnifying glass. These gave a sharp image in the middle of the

Les triomphes
In France, Emperor Napoleon III used photography extensively to document his triumphs and explorations, especially in North Africa and Egypt. More constructively, in the 1850s he sent teams of photographers out to record the medieval buildings of France.

1855 Alexander Parkes patents the first synthetic plastic, which will later be called celluloid, and dies before realizing how much he has to answer for.

1857 In Britain the Matrimonial Causes Act states that a husband still has responsibility for his wife after the marriage has ended and should therefore pay alimony.

1859 Construction of the Suez Canal begins as 30,000 Egyptian forced laborers start digging.

picture, but the edges tended to be fuzzy and out of focus. To the architectural photographer, this was unacceptable. In 1840 the flat field lens was developed, again at the same time but independently, by two opticians, John Dallmeyer and Hugo Steinheil. This ensured that every aspect of the image was sharp and undistorted. And in 1851, the English sculptor Fred Scott Archer developed the "wet-plate" process, sensitizing sheets of glass with silver salts using collodion, a mixture of gun-cotton and ether (initially used for forming an "artificial skin" over minor wounds). The wet-collodion process allowed large glass negatives to be exposed in the camera and had only one minor drawback ... the word "wet" is a clue. Once the coating had dried, it didn't work, so the photographer had to coat and expose the plates on the spot. This can be a bit tricky when you're faced with the midday heat of the Valley of the Kings and the swarms of suicidal flies flinging themselves by the fez-full into your drying emulsion.

So we have to admire the tenacity of the likes of *Francis FRITH* (1822–98) and *Francis BEDFORD* (1816–94), who made the arduous trip to Egypt and the Middle East many times during the period. Frith produced a series of 16" x 20" plates of the pyramids and

Francis Frith in party mood (self-portrait, 1857).

Box of tricks

The equipment of even an amateur mid-19th-century photographer could weigh 120lbs. The affluent employed porters, but it was not uncommon to see the less fortunate transporting their camera gear in wheelbarrows or handcarts. In 1853 a portable darkroom in a suitcase was marketed, allowing the photographer to set up on location. Because of the amount of water needed, lake- or riverside photography suddenly became a very popular pastime.

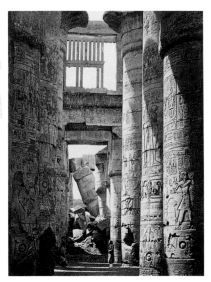

Sunlight and shadow in the interior of the Hall of

Columns at Karnak, by Francis Frith (c. 1857).

other ancient Egyptian sites. Back in England he "mass-produced" positives from these plates, which were sold directly to the public or pasted into travel books; but sadly, he is probably best remembered for introducing the picture postcard.

1850 Jersey cows are imported to the U.S., where they are much prized for the high butter-fat content of their milk.

1852 John Everett Millais paints *Ophelia*, based on Shakespeare's suicidal heroine.

1854 Europe has 22,530 miles of railroads connecting most of the major cities.

1850s

May I Present Myself?

The carte-de-visite and the portrait studio

The images of early Victorians that have come down to us suggest a dour breed. Their streets are eerily empty, devoid of life, with gray, featureless skies and the occasional half-glimpse of a human form, or horse and cart, semitransparent and ethereal. We think of them as unsmiling sourpusses to a man.

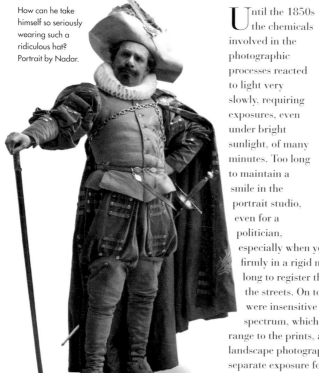

How can he take himself so seriously wearing such a ridiculous hat? Portrait by Nadar.

Photo booths
The modern equivalent of the carte-de-visite is probably the photo booth, first introduced in the 1940s. For only 25 cents you could be taken by surprise four times in a booth and then miss your train while you waited for the images to emerge from the mysterious depths of the machine. Having flung the still-wet prints into your bag, you could later enjoy the time-honored practice of carefully pulling them apart without ripping the pictures.

Until the 1850s the chemicals involved in the photographic processes reacted to light very slowly, requiring exposures, even under bright sunlight, of many minutes. Too long to maintain a smile in the portrait studio, even for a politician, especially when your head is being held firmly in a rigid metal clamp; and too long to register the crowds thronging the streets. On top of this, the plates were insensitive to the red end of the spectrum, which gave a strange tonal range to the prints, and often meant that landscape photographers had to take a separate exposure for the sky that would be pasted in to the finished foreground image.

1856 *Harper's* goes weekly. (*Harper's Monthly* was founded in 1850.)

1858 Big Ben begins chiming in the clocktower of London's Westminster. It is tuned to E and the lowest notes are used for the quarter hours.

1860 Frederick Walton invents linoleum by oxidizing linseed oil.

CALLING CARDS

The development of new processes meant that exposure time could be shortened, so that the portrait studios were no longer the domain of the rich and tenacious but accessible to those of more limited means as well. The tin-type, invented by Hamilton Smith and the Neff brothers in 1856, provided a durable and portable memento of those nearest and dearest; but one of the most significant steps toward a proletarian photography came with the carte-de-visite, patented by André Disdéri in 1854. These were essentially "cheap and cheerful," easily reproducible, multiple paper portraits that needed little expertise or ceremony to create. Usually of poor quality, these personal calling cards were a forerunner of the celebrity picture, and those featuring royalty or the stars and grotesques of the day were highly sought after. Disdéri's invention suggests interesting parallels with the modern photo booth, as both served a similar need.

The accessibility of these new emulsions had another effect: it allowed a more intimate form of portrait to be made. This, combined with the growing use of electric lighting, meant that the photographer had more control over the pose and expression

"Come up and see me some time." Being photographed by Nadar is all the rage.

of the sitter, introducing a vigor and dynamism into the process.

One of the first exponents of this new style was *Gaspard Félix Tournachon* (1820–1910). Tournachon, universally known as "Nadar" and by all accounts larger than life, was by the 1850s widely patronized by the élite of Parisian society.

The democratization of photography brought with it a proliferation of the seedier products of the medium, as Paris, which had been the world center for the production of printed pornography in the 18th century, took this new form of reproduction firmly to its bosom in the 19th.

Box of tricks

One of Nadar's portrait sitters, the French writer Balzac, had an intense fear of being photographed. He believed that all physical bodies were made up of layers of ghostlike images, laid on top of each other. Every time he had his picture taken, one of these "layers" would leave his body and be transferred to the photograph. This might not advance our understanding of the photographic process, but it probably explains why the French government banned absinthe.

Balzac's greatest fear.

1850 Elizabeth Barrett Browning's book *Secrets from the Portuguese* is published, a collection of her passionate love letters to Robert Browning.

1851 Boucicault's *Love in a Maze* opens at London's Princess Theatre.

1853 Swedish inventor J.E. Lundstrom patents the safety match.

1850s
In Olden Days a Glimpse of Stocking
Photography and sex

Of course it wasn't stocking that fans of this genre were really seeking a glimpse of; far from it (well, not that far, actually). The early 19th century was familiar with the depiction of nudity: within the lexicon of fine art, the nude figure was a familiar artifice, purporting to allude to scenes from classical mythology, religion, or literature.

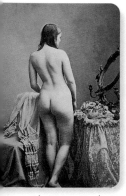

John Watson: "Academic Study," 1855. Very erudite, I must say.

A walrus-mustached gent could safely hang these paintings on his study wall where he could reflect at leisure on the allegorical qualities of the work. Yep! The nude in fine art or, indeed, sex in fine art, was protected from suggestions of prurience by the distance between the viewer and the subject; while the painting could have been created "from life," there was still an acceptance of interpretation or mediation by the artist, and a belonging to an artistic tradition that could be traced back to Greek or Roman times. They were somehow "unreal" and remote. True pornography, which had no real artistic pretensions, belonged to the educated and well-to-do, essentially individuals who considered themselves "above" any corrupting influences, and the masses, who created a market for crudely printed engravings and woodcuts.

Family snaps
In 1874 *The Times* carried a report of a police raid on the studio of Henry Hayler, a London photographer, in which they seized over 130,000 obscene pictures. This brave attempt to rival Paris as a center for the mass production of porn earned Hayler and the rest of his family, all athletic participants in the pictures, a lengthy prison stay.

Victorians taking a prurient interest in what the butler saw.

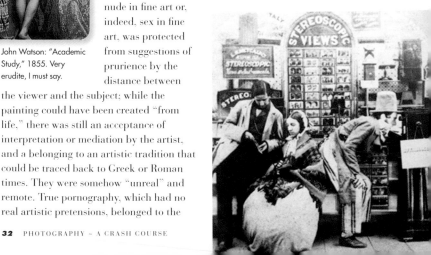

1854 A Philadelphia dentist called Mahlon Loomis invents a kaolin process for making false teeth.

1856 U.S. adventurer William Walker storms Nicaragua and becomes its dictatorial president. He is overturned the following year and executed in Haiti in 1860.

1858 The House of Worth opens in Paris and will soon be supplying gowns to royalty everywhere.

IN THE FRAME

The King of the Étude in late 19th-century Paris was **Guglielmo Marconi,** *who titled his studio "Photographe d'École Des Beaux Arts" (translated as "Nudes Galore"). His work seems to have centered on the fine art tradition. Others, like* **François Jacques Moulin,** *working in a studio in Montmartre, produced not only mainstream nudes but dabbled in some under-the-counter pictures.*

IT'S ACADEMIC

In Paris, paintings had to be registered with the Academy, who acted as unofficial censors. Early photographic nudes went through a similar process and were known at first as *études académiques*. But, as the production of photographs became more accessible, a glut of small studios without any pretence of expertise sprang up to cater for this proliferating market. The type and nature of these images had moved so far away from anything that could be called a "figure-study" that there was little point in the Academy attempting to control the output, and by the mid-1800s Paris was establishing itself as the world's major producer and exporter of seriously hard-core pornography.

Anonymous naked nymphs by an anonymous [clothed] photographer.

As Victorians tramped off to the "Dark Continent," their irrational desire to measure everything that moved induced them to photograph "natives." usually in their "natural" state, for eager consumption back home. By 1860, this golden age of pornography came to the attention of the gendarmerie, and it wisely went underground for the next 100 years.

Box of tricks

One further photographic invention that found a natural home in the porn market was the stereoscope. Two images of the same subject taken side by side will, when viewed appropriately, give a convincing sensation of three dimensions. This technique had been used extensively by other photographic conventions, but its ability to allow the viewer to gaze at leisure at seemingly "real" pictures of unlimited hanky-panky meant that this was a "must-have" item for many a Victorian household—obviously, as with the later Polaroid camera, purchased for landscapes, etc.

1860s~1870s

Blazing Trails and Laying Rails
Early visions of the American landscape

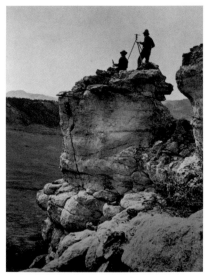

Another step forward: William Henry Jackson's "Topographical work," 1874.

While we must admire the travails of Frith and co. in photographing the Middle East, their achievements pale a little when we think of the work of Timothy O'Sullivan, William Henry Jackson, Eadweard Muybridge, and Carleton Watkins in the American West during the mid-19th century.

W illiam Henry JACKSON (1843–1942) particularly merits a mention for his sheer "can-do" stubbornness in taking a giant camera—producing a 20" x 24" glass plate negative—high into the Rocky Mountains. It's almost unimaginable in these days of compact cameras to have a physical sense of what this involved. But this was America—big country, big camera. Jackson worked for the Geological and Geographic Survey of the Territories in 1870, and the resultant body of work was instrumental in Congress establishing Yellowstone National Park in 1872.

Timothy O'Sullivan (1840–82) cut his photographic teeth working as an assistant to Matthew Brady's Photographic Corps covering the American Civil War, but split with Brady over his disinclination to credit an individual's work or to let them keep their negatives. (If you want to annoy a photographer, ask if you can keep their negatives—never fails.) O'Sullivan, like Jackson, moved into topographic survey work for the U.S. government and for the emerging railroad companies. As well as being among the first to discover the rapids of the Grand Canyon (not a good idea if you're on a raft), he also produced some of his best pictures, notably those taken in the Canyon de Chelly, Arizona, in the 1870s.

1868 Sixteen-year-old Rama V becomes King of Siam; he will found the modern state of Thailand and rule till 1910.

1876 Art critic John Ruskin denounces Whistler's *Nocturne in Black and Gold: The Falling Rocket* and Whistler brings a libel action; the case bankrupts Whistler, who is awarded damages of one farthing.

1879 Werner von Siemens demonstrates an electric locomotive at the Berlin Trades Exhibition.

WATKINS AND MUYBRIDGE

While Jackson and O'Sullivan were primarily recording the landscape, *Carleton WATKINS* (1824–1916) and *Eadweard MUYBRIDGE* (1830–1904) had a more aesthetic vision for their work, a sense of wonder and a spiritual response to their subject—in effect, they were early hippies. One of the problems with photographing the landscape, especially a BIG landscape, is how to take the sensation of actually physically "being there," with all of its perspectives, scale, sounds, and emotional impact, and transpose it onto a very small piece of black-and-white paper.

A big landscape: Carleton E. Watkins's "Washington Columns, Yosemite no. 81," c. 1866.

IN THE FRAME

If we think of Watkins as mildly insane, in Muybridge's case Elvis had definitely left the building. Muybridge was an Englishman working in San Francisco in the 1860s, again producing topographic work for the government. He is kindly described as eccentric, having changed his name from Muggeridge as a homage to the Anglo-Saxon kings that once ruled Kingston-on-Thames. However, this was before he suffered a severe head injury after being thrown from a stagecoach in Texas in 1852, so there's no real excuse. With the possible exception of a 360-degree panorama of San Francisco, his landscape work, again including Yosemite, is not his main claim to a coveted place in photography's roll of honor. Eadweard Muybridge is in fact widely saluted as the inventor of the moving image (see page 36).

"Invoking the transcendental" is really another term for "composition"—if you believe that God made the mountain, then that's what you'll see in the end result, regardless. If you don't, you've got a large rock, not in itself a bad thing. Watkins was a catastrophist, who believed that the landscape was a physical manifestation of divine wrath. This might explain much inner-city planning, but you still wouldn't want him as a visiting lecturer.

1870 The aurora borealis is seen in southern England in a rare arch shape.

1872 Lord Kelvin invents a machine for making depth soundings, enabling the mapping of seabed features and the discovery of the mid-Atlantic ridge.

1875 Captain Matthew Webb is the first person to swim the English Channel; it takes him 22 hours and he swims the breaststroke.

Zoetropes
Muybridge's pictures were widely sold as sets to be cut and pasted into a new novelty, the Zoetrope. This was an open drum with a series of vertical slits in the side. When the drum was rotated, the pictures glued to the inside appeared as though they were moving.

1870s
They Almost Move
Sequential pictures and animal locomotion

Eadweard Muybridge.

What Karl Marx probably meant to say was that a society has reached a state of social surplus when men can sit around the camp fire and ask those fundamental questions of existence, such as: when a horse is galloping, is there a moment when all four hooves are off the ground? and, do you wanna bet? It would be nice to think that something as fundamental to the modern world as film might have sprung from saner, more noble beginnings, but as another Marx (Harpo) observed, no doubt thinking of Muybridge, "There ain't no sanity clause."

The former governor of California Leland Stanford commissioned Muybridge to prove this horse-leaping premise to win a bet that he had placed with his equally rich and idle sports jock buddies. Initially Muybridge attempted to prove Stanford's thesis with a single image, but the results were inconclusive. He had to take time out in 1874 to be tried for the murder of his wife's lover, Harry Larkyns. We shouldn't by now be surprised that his defense used an insanity plea. He was acquitted (ironically because the jury thought that Larkyns got what he deserved) but left the States for three years before returning to recommence his hoof-related project. He constructed a row of 12 cameras that would be triggered by the horse galloping past, and with this he was able to prove the hovering horse theory—much to the delight of Stanford.

This trivia out of the way, Muybridge realized that he had chanced upon his life's work. Over the next decade he

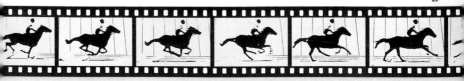

1877 In cricket, the first Test Match between England and Australia is played in Melbourne. Australia wins.

1878 The newly invented telephone is demonstrated to Queen Victoria at Osborne House.

1879 The railroad bridge over the Tay River collapses carrying the Edinburgh to Dundee train and about 90 people are killed.

produced over 20,000 photographs showing the human body, along with a variety of animals and birds, performing a range of tasks in this sequential form, which were published in the 11-volume *Animal Locomotion*. Muybridge lectured and presented his work throughout America and Northern Europe. He devised a mechanism, which he called the Zoopraxiscope, which allowed the images to be shown in rapid sequence, giving the appearance of movement.

One of the motivators of the great horse debate was a French professor of physiology, *Étienne Jules MAREY* (1830–1904), who in 1868 had published his musings on animal movement and corresponded with Muybridge about his own experiments. Marey began by taking several exposures on a revolving plate inside

Muybridge's Zoopraxiscope (1889); an early movie camera.

what he described as a "photo-gun." He improved his technique by devising a method of pulling the film past a quick-firing shutter, resulting in multiple sequential exposures on a single picture delineating the sequential movement of a bird's wings in flight.

Both photographers carried on with their work without ever showing much interest in the new art form to which they had jointly given birth. It was left to others over the next century to perfect the techniques of the moving image.

You'd get a fright if someone tried to take your picture with one of these.

Box of tricks

Photographers and filmmakers soon realized that the speed or frequency at which movement was recorded and played back allowed endless creative possibilities (or opportunities to pretend to be artsy). Movement recorded at 18–24 frames a second gave the impression of naturalistic motion. If you increased the speed of filming to 36 frames a second and projected normally, you got slow motion. By taking a picture of, for instance, a flower opening, every second, and projecting normally, you achieved "time-elapse" pictures in which hitherto unobservable events could be brought to the screen.

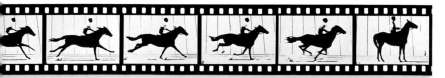

1880 The *New York Daily Graphic* prints a half-tone photograph, the first to appear in a newspaper. It shows a shanty town.

1883 Krakatoa erupts off the coast of Java, causing spectacular red sunsets around the world.

1884 Janice Deveree of Bracken County, Kentucky, has a 14 in beard.

1880s
They Do Now
The Lumière brothers

The Lumière brothers share an intimate moment. They believed that cinema didn't have a future.

If you knew nothing of moving pictures, the sight of a train hurtling toward you as you sat in a darkened room in the Grand Café in Paris at the end of December 1895 might have caused you some small *measure of concern. You might, indeed, have panicked and run screaming to the exits. While Wes Craven would have found this reaction appropriate, the* LUMIÈRE *brothers, Auguste (1862–1954) and Louis (1864–1948), who mounted this very first screening of cinema shorts, had mixed feelings.*

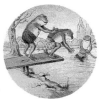

The magic lantern version of an early Budweiser commercial.

Since then, cinema audiences have acquired the language of film and are able to suspend disbelief and make sense of a disjointed narrative. But these first audiences were overwhelmed by the sheer novelty and unfamiliarity of the experience. Five years earlier *Thomas Edison* (1847–1931), who invented virtually everything, had capitalized on this when he opened his first Kinetoscope Parlor in New York. This was essentially a "peep show," each spectator alone in their experience of the piece. Our grandparents would remember kinetoscopes as "What the Butler Saw" machines, the furtive highlight of many a day trip to the beach. But for the origins of the true "shared" cinema experience, it is the Lumière brothers, with their often mundane subject material— workers leaving a factory, fishing boats setting sail, etc.—to whom we must turn.

1886 Dr. John Pemberton, an Atlanta pharmacist, launches Coca-Cola as a tonic.

1888 Prostitutes are murdered and disemboweled in London's East End by "Jack the Ripper." It will later be alleged that they were killed by agents of Queen Victoria, trying to hush up a scandal involving her grandson.

1889 Texas outlaw Belle Star is shot dead two days before her 41st birthday.

THE FIRST BLOCKBUSTER

One short film does stand out, and we can carbon-date slapstick comedy back to its first screening. You know the routine: you're watering the garden and the hose suddenly stops flowing; you look into the end of the tube, whereupon the mischievous little scamp takes his foot off the hose and wham!—water in face. We've seen it a thousand times, and the Lumière brothers are the ones to blame.

The Lumière brothers felt that cinematography was little more than a novelty, but within a year of their first showing, many versions of the cinematic process had sprung up on both sides of the Atlantic. The moving image developed at a phenomenal rate, spawning studios in France, North America, and the UK.

IN THE FRAME

Between 1896 and 1914, **Georges Méliès** *(1861–1938) created over 500 films. Drawing on his love of magic tricks and theater, he developed "stop motion techniques," allowing objects and people to appear and disappear from the screen—seemingly crude by today's standards but wondrous to the audiences of the time. He would stop the camera in the middle of a scene, then an actor or prop could be introduced or removed and filming recommenced. Obviously no one is suggesting that this technique is used by modern "magicians" in those wonderfully understated TV stunts.*

Box of tricks

The illusion of movement is believed to be caused by a phenomenon known as the "persistence of vision," where an image lingers in the brain for a fraction of a second, allowing photographs of motion to be mentally "joined" together.

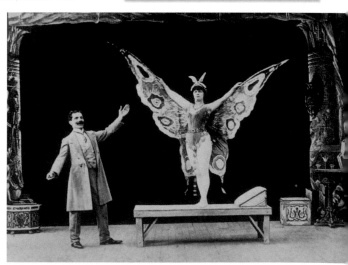

Méliès makes a woman dressed as a butterfly appear out of thin air.

1857 A school to translate foreign literature, known as the Institute for the Investigation of Barbarian Books, is established in Japan.

1864 Charles Dickens is involved in a train crash in Kent and has to clamber back into the damaged carriage to retrieve the manuscript of *Our Mutual Friend.*

1874 Major Walter Wingfield patents the game of lawn tennis under the name of "Sphairistike."

1850~1910s
Line Engravers and Picture Chasers
Early newspaper photography

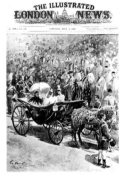

Queen Victoria makes the cover in 1897.

Remember our caveman friend? To record the events of the world around him, he painted or scratched scenes of everyday life and the spirit world on the cave walls. He was a proto-journalist. From the pictograph, the hieroglyph, and the papyrus scroll to the wood block, the illuminated manuscript, and the printing press, man has always found means to meet his need to record both domestic and momentous events.

Interview techniques
One of the strangest uses of the photograph in early illustrated magazines was the "photo interview" —a series of images of the interviewer and interviewee in discussion, often with exaggerated gestures to convey expression, captioned by text from the interview. This was a genre that was thankfully overtaken by the advent of television. One of the earliest examples, from 1886, shows Nadar in conversation with the French scientist Michel-Eugène Chevreul.

By the 1860s, there had been a shift away from text-only newspapers, although it took considerably longer for some of the broadsheets to catch up with this concept. The *London Illustrated News* captured the mood of the time with an extensive use of woodblock engravings livening up the content. A whole subindustry fed the need for images, copied from photographs, in a form that could be easily printed. There was no simple, mass-producible method for printing the range of tones and details of a "true" photograph.

To reach a mass audience, photographs had to be contact-printed in bulk and glued into the publications; or, conversely, shown using the "magic lantern," an early form of slide projector.

A magic lantern (1880): useful for boring your friends with all those family vacation shots.

1880 In London, the first phone book is printed, containing 255 names.

1897 In his autobiographical *Inferno*, Strindberg describes his mental illness in Paris between 1894 and 1896.

1907 President Theodore Roosevelt shakes hands with 8,513 people at a function at the White House on New Year's Day.

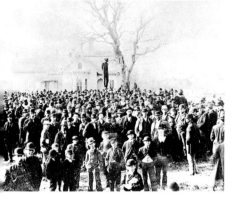

An ugly American lynch mob get their man, 1880, and a photographer catches them in the act.

by every major publication. This created a hunger for images. There was no longer the luxury of time to linger over composition—news events required speed of production and speed of delivery.

Picture takers and picture snatchers were often exactly that, beg, borrow, or steal. A whole new profession grew to satisfy this need. The photojournalists, subscribing to an ethical spectrum that ranged from the moral high ground to the murky depths, were all united by the urge to "show," to highlight, and to reveal the follies and fallacies of humanity.

GOING DOTTY

For a photograph to be printed alongside the text, the image would have to be given a relief texture to create an etched plate that could hold and print the correct amounts of ink.

In an idle moment you might look closely at any modern printed photograph and you will see that it's made up of thousands of dots. It was this discovery of the "half-tone" screen in 1880 and the first photographic reproduction in the New York *Daily Graphic Paper* that opened the floodgates for the printed image. The woodblock had allowed the "artist-engraver" an opportunity to "interpret," or tinker with, the original image; it is obvious that they often overdramatized what they saw, and by the 1880s their work carried little credibility. The photograph was perceived as more "real" and immediate, and within a decade, the half-tone was almost exclusively adopted

IN THE FRAME

*In 1928, **Tom Howard**, a reporter for the New York Daily News, taped a camera to his ankle to take a picture of the execution of Ruth Snyder in the electric chair. At the "decisive moment," he surreptitiously pulled up the leg of his trousers and took the picture. What's even weirder is that there is a web site dedicated to the history of the electric chair.*

1852 *Uncle Tom's Cabin*, by Harriet Beecher Stowe, has such a strong influence that it is sometimes reckoned to be one of the causes of the Civil War.

1855 The first kindergarten is opened in Wisconsin by the wife of a German immigrant.

1858 Some nuggets are found on the Fraser River and a gold rush to British Columbia begins.

1850~1870

War is a Photo Opportunity
Crimea and the American Civil War

In the 1800s war had proper rules. It was a gentleman's game—none of this messy running around and bombing from high altitudes that we have today. You stood your men in neat rows and watched them get blown up from the top of a distant hill. And as wars normally took place a long way from home, you could usually bury your mistakes, even if you accidentally sent your cavalry headlong into the massed Russian artillery. After all, a fellow must be allowed an occasional minor misjudgment, and anyway, who's to know? Any itinerant daubers or scribblers around at the time were either in the pay of the military or else deemed unreliable.

IN THE FRAME

*While Fenton attempted to sanitize, photographers of the American Civil War, notably **Mathew Brady** (1823–96) and **Timothy O'Sullivan** (1840–82), had no such compunctions. Brady's friendship with Abraham Lincoln enabled him to travel freely with the Northern troops. His pictures showed the harsh realities of conflict, the maimed and the dead. He set up a photographic corps and toward the war's end had teams of photographers working under his name. Following his split from Brady, O'Sullivan branched out on his own, most famously covering the Battle of Gettysburg, where 43,000 men were killed or wounded in the three days of fighting.*

Oh dear! The controllers of information were about to get a serious shock to the system, a shock that would last from the Crimea to the Vietnam War, as the battlefield began to be invaded by hordes of independent photographers. While war paintings had dwelled creatively upon glory and gallantry, early photographers

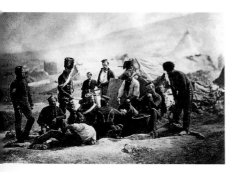

Soldiers taking a break in the Crimea, by Roger Fenton (c. 1855).

1860 Belgian inventor Jean Joseph Étienne Lenoir patents an internal combustion engine in Paris.

1863 General Stonewall Jackson is accidentally killed by his own men during the Battle of Gettysburg.

1869 Elizabeth Siddal's coffin is opened up after Dante Gabriel Rossetti changes his mind about some poems he had interred with her.

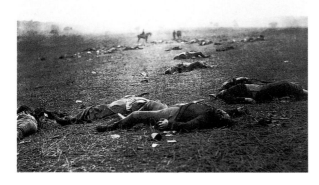

"Harvest of Death, Gettysburg," by Timothy O'Sullivan, 1863.

were inevitably drawn to the detritus of battle and the aftermath of conflict. Long exposures, wet plates, and bulky equipment were not conducive to action shots.

When the British went to the Crimea in the mid 1850s, it was initially seen as a "popular" war, but as negative news reports, mainly by William Russell, *The Times* correspondent, filtered back to an influential middle-class readership, public opinion was seen to waver. In 1855, *ROGER FENTON* (1819–69), a noted photographer and favorite of the Royals, was commissioned to sail to the Crimea and bring back "positive" images of the conflict, but the images he brought back could not be glamorized. They showed the squalor of the camps and the superior conditions of the officer corps. More

significantly, images of the battlefields, taken long after the engagements, still demonstrated a sense of the horror and confusion. The "Valley of the Shadow of Death," the scene of the charge of the Light Brigade, littered with uncountable cannonballs, triggers the imagination even today.

The reportage photograph carries a certain authority. We have an implicit faith in the fact that these images convey a notion of the truth or reality of an event. The photographer, with his opinions, agendas, and failings, is forgotten. Acutely, this relationship is at its most fraught when covering warfare, when the dynamic ingredients of confusion, censorship, and propaganda are added to the pot. War is chaos on a grand scale. The photographer can only show random glimpses that may or may not provide a distant insight, but the public faith in the truth of the photograph makes it a powerful tool for informing and manipulating public opinion.

Guard your van

Mathew Brady and his van-load of equipment got caught up in shell fire during the battle of Bull Run. His cameras were destroyed and he wandered the battlefields dazed and lost for three days. This narrow brush with fate didn't dampen his enthusiasm, however— he was soon re-equipped and back in the thick of it. During the Crimean War, Roger Fenton's van provided a juicy target for the Russian artillery, but luckily his exposure times were down to about 15 seconds.

A CRASH COURSE **43**

1882 The first sex information center is opened in Amsterdam by a woman doctor, Aletta Jacobs.

1883 James O'Neill, father of Eugene, plays the Count of Monte Cristo on stage for the first time. He will repeat the role 6,000 times over the next 8 years.

1891 Oscar Wilde's *Picture of Dorian Gray* typifies the decadence of the era.

1880s~1900
The Caring Eye
Natural photos

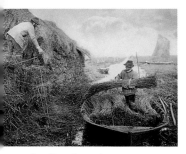

Peter Henry Emerson's "Ricking the Reed" (c. 1885).

War produces an extreme form of documentary, and the level of cannon fire in the vicinity can have a profound influence on the photographer's choice of camera position. While the rules of war photography were being established in the Crimea and North America, Peter Henry EMERSON (1856–1936) was pursuing an altogether more gentle subject matter in the Norfolk Broads of England.

Reacting against the fine-art values espoused by Henry Peach Robinson, Emerson wrote a treatise entitled *Naturalistic Photography* in 1889. He suggested that photographers should draw on the world around them for their inspiration and record the subject as they find it. He illustrated his philosophy of an independent art with a series on life in the Broads, exhibited in 1885.

His book contains those lists of do's and don'ts that mark the battlelines between the Naturalists and Constructionalists still in place today. Most of them make a lot of sense, while some are just a bit strange: "It is not the apparatus that chooses the picture, but the man who wields it." (that's OK); "Do not climb a mast or sit on the weather cock of a steeple to photograph a landscape." (that's one of the weird ones).

1895 Bridget Clary, aged 27, is burned to death for witchcraft in County Tipperary, Ireland.

1896 Magnus Hirschfield attributes homosexuality to a congenital make-up that cannot be changed, despite being linked to glandular secretions.

1900 The first woman to win an Olympic gold medal is British tennis player Charlotte Cooper.

Not surprisingly. this work unleashed a hornet's nest of ridicule and argument. But Emerson was setting some of the ground rules for what became documentary photography. Social reformers began to see the possibilities of photography for bringing the plight of the dispossessed to a wider audience. In New York. *Jacob Riis* (1849–1914) sought to improve the lives of slum-dwellers and his book. *How the Other Half Lives* (1890). attracted the attention of future president Theodore Roosevelt. And in the early 1900s *Lewis W. Hine* (1874–1940) showed the wretched

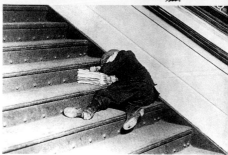

Lewis W. Hine captures a newspaper delivery boy taking a nap on the job (1910).

working conditions of the immigrant underclass in New York. He went on to document child labor in factories. mines. and mills throughout North America. and the impact of this work helped force legislative reform. Hine was not averse to a little subterfuge. secreting his Graflex hand camera in a lunch box to picture the working conditions of child laborers.

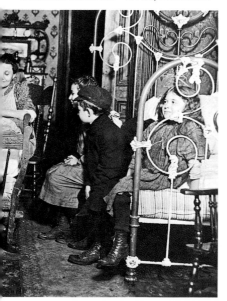

Overcrowded living conditions for a mother and six children in Chicago, 1910, by Lewis W. Hine.

IN THE FRAME

Paul Martin *was a picture engraver working in London who was astute enough to recognize that the half-tone block would involve some "restructuring" of the industry, and that he was ripe for "downsizing." He took up photography and using the newly marketed "Facile" hand camera, which was held under the arm and disguised as a small suitcase, he took many "candid" pictures of London's poor as part of his crusade for reform.*

1899 Cans of Carnation evaporated milk are supplied to gold-seekers in the Klondike.

1901 The Union of Christian Women for Temperance launch a national campaign against kissing on the lips, on the grounds that it is unhygienic.

1908 Kenneth Grahame's novel *The Wind in the Willows* is published and the characters Ratty, Toad of Toad Hall, and Mole become children's favorites.

1899~1927
The Quiet Passion
Eugène Atget's Paris

Among the radical and avant-garde work on show at the "Film und Foto" exhibition in Stuttgart in 1929, a series of photographs stood out. They were at first glance unassuming and, worse still, apparently unmodern images of Paris—streets, shop fronts, and workers, all produced with a simple, unpretentious vision. Work at the exhibition, a glorification of Modernism, had been chosen by some of the most progressive artists of the day, and these images were by Man RAY (1890–1976), former wild child of the Dadaists and top Surrealist. What was going on?

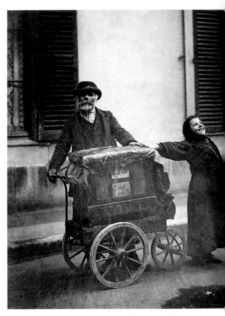

Organ grinder and singing girl pose for Atget, 1898.

There are some people who only find their true path after many false twists and turns. *Eugène ATGET* (1857–1927) died in obscurity and relative poverty after more than two decades spent quietly pursuing his vision: the documentation of

Box of tricks

Man Ray offered to lend Atget one of the new, small, hand cameras. He refused, saying that the snapshot camera was "too fast" for him, and that slow deliberation was the essence of his method.

the Paris that he loved, carried out with humility and a gentle, caring eye. During his lifetime the worth of his work went largely unrecognized, and it was left to Man Ray and his protégée, *Berenice ABBOT* (1898–1991), to bring his photography to a wider audience and to establish him as one of the true visionaries of the medium.

Born in Bordeaux, Atget first joined up as a seaman, and it wasn't until he was 41, and had tried to earn a living as an actor and then as a painter, that he finally discovered photography.

1913 American conjuror Chung Ling Soo is shot on stage in London during his act, which involved catching bullets on a plate.

1920 King Alexander I of Greece dies after being bitten by his pet monkey.

1927 John Wayne appears in *The Drop Kick*, the first of his 153 movies.

A MAN OF PRINCIPLE

Atget was not remotely concerned with the debates raging back and forth about photography as art. He was an obsessive, who cared nothing for self-aggrandizement (this is hardly typical of your average photographer). He never exhibited or published any of the 10,000 images of Paris he took, but sold his pictures to artists, illustrators, and museums.

As more compact, hand-held cameras and faster film came onto the market, he persisted with his old plate camera and tripod. Yet, as Man Ray and Abbot first discerned, Atget's concerns and philosophy foretold the growth of the modern style and the new realism of the late 1920s. His photographs dealt with ideas of a society, a culture, discovered through its artifacts and edifices. He communicated his own relationship with that culture through his individual approach and his selection of subject matter. Atget wanted "to photograph everything," and he very nearly succeeded.

In 1930, the influential book *Atget: Photographe de Paris* was published. It is still revered by photographers today. His place in the lexicon of photography was firmly established with a major posthumous exhibition of his work at the Museum of Modern Art in New York

When your number's up

The numbering system Atget used for his 10,000 images left a mystery for future curators and researchers. There seemed to be no rational explanation for his categorizations and many obscure theories were postulated. After much scratching of heads, it turned out in the end that Atget had merely adopted the classification of types of subject used by the card files in his local library. I suppose that's as good as any.

in 1969, and further volumes of his work were edited by Berenice Abbot.

In 1929, she moved to New York to make a survey of the city that she hoped would be as comprehensive as Atget's of Paris. She won state backing, and her book, *Changing New York*, was published in 1939.

Atget's "The Rag Picker" hauling his cart.

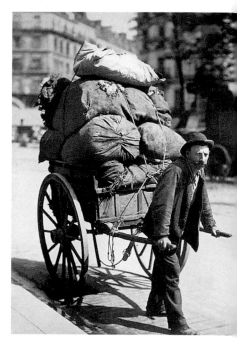

1910 Constantin Brancusi's sculpture *The Kiss* is exhibited in Paris, showing two figures merging into one.

1921 A baby is born in East London with 14 fingers and 15 toes.

1925 Prohibition agents Izzy and Moe are sacked for being too successful at their job and annoying their superiors by getting too much personal publicity. They've made 4,392 arrests in five years.

1910~1940

Underbellies and Goodfellas
Weegee and crime photography

A self-portrait of Weegee holding his Speed Graphic camera.

While the majority of photographers mused about notions of beauty, the wonders of nature, or, even more oddly, the majesty of the human spirit, there were others who looked behind the façade, into the murkier corners and the blood-splattered sidewalks of society. There are apparently some people who prefer to be awake at night, finding their entertainments and pleasures behind red plush curtains, in smoke-filled bars, or under streetlights. Naturally, photographers follow.

Gyula HALÁSZ (1899–1984) was born in Brassov, a village in Transylvania, so he was conditioned from birth to function more easily in the hours of darkness. He followed the time-honored tradition of changing his name, to Brassaï, moved of course to Paris, and immediately took up the camera.

It was his friend André Kertész (more on him on page 80) who advised him to move from journalism to photography, and during the late 1920s and early 1930s he produced a series of photographs based on Parisian nightlife, bistros, and brothels, published in 1933 as "Paris de Nuit."

Across the Atlantic, an Austrian-Hungarian émigré, *Arthur FELLIG* (1899–1968), was recording the sticky underbelly of life in New York. He acquired the nickname "Weegee" as a result of his seemingly uncanny ability to arrive at the crime scene before the police. ("Ouija"—get it?) The fact that this was easily explained away by his having a police radio in his car and a vested interest in getting there first didn't get in the way of a good byline.

1934 The Strahov Stadium, the world's largest, is completed in Prague. It can hold 240,000 spectators and is used for mass displays of up to 40,000 gymnasts.

1935 The first Penguin paperback is André Maurois's biography of Shelley.

1940 In Canada, there is a mad rush to get married between July 12 and 15 after it is announced on the 12th that men who are unmarried on the 15th will be called up to fight.

He preferred to be known as Weegee the Famous. Shy and retiring this guy isn't.

Arthur's ... okay, *Weegee*'s, work was distinguished by his early use of flash photography, which lent a dramatic, almost film-noir feel to his work. He published his work as *Naked City* in 1936.

An obscure commercial photographer, E.J. Bellocq, was working in New Orleans in the early 1900s. After his death in 1949, an executor cleaning out his desk discovered a series of glass negatives. These were later purchased by the photographer Lee Friedlander and printed in the 1960s. They constitute a body of work documenting the lives of New Orleans prostitutes of the time. There was no way of knowing what motivated this work: Bellocq left no notes to explain

whether this was a private project or commissioned work, but these images are widely seen as a forerunner of modern photojournalistic photography.

Box of tricks

Using flash photography at night highlights the foreground and leaves the distance in deep shadow, giving a theatrical effect to the image. As the light from the flash travels further away from the camera, its strength becomes progressively weaker, thereby reducing the amount of exposure on the negative.

Looking at the dark side.

"Death of David 'the Beetle' Beadle" by Weegee, with a policeman looking on.

Reflex action

Alongside Weegee's work with the dark and dangerous was a compassionate, humanistic streak he could never shake off. One of his stranger images shows the dead or dying body of a man dragged from the water surrounded by onlookers and medics. A swimsuited girl, the girlfriend, kneels next to the body. She looks up, sees the camera and automatically smiles.

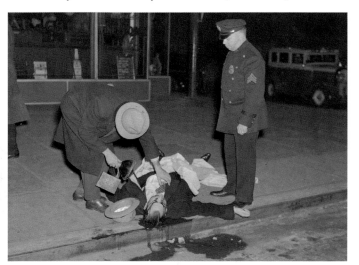

1852 A Danish scientific station is set up in Pearyland, Greenland, more than 900 miles north of the Arctic Circle.

1864 A grasshopper plague in the Great Plains disrupts the U.S. wheat crop.

1871 The world's first margarine factory opens in Oss in the Netherlands.

1850s~1900s

Flash! Bang! Wallop!
New technologies, 19th-century style

The first color photograph, shown in 1861, by James Clerk Maxwell.

As we have seen, wet-collodion plates allowed high-quality photographs to be produced but suffered from minor setbacks, such as the need for a portable darkroom. By the mid-1860s, dry plates were introduced; these could be coated and dried back in the lab and taken to the location, exposed, and returned to the darkroom at the

photographer's convenience for later development. Of course, there had to be a downside, namely the slow action of the subsequent emulsion, which needed exposures several times longer than the "wet" equivalent and thus limited the subjects for which dry plates could be used.

On reflection ...
One simple way of controlling the light falling on your subject is to use a reflector. Positioned out of frame, even a piece of white card or polystyrene can bounce back up to 80 percent of the light, while reducing the harsh contrast.

As we have seen already, in 1871 a gelatin-based emulsion was developed by Richard Maddox, an English doctor, which allowed both film speed and portability. (Since gelatin was produced by boiling up animal

bones, it meant that true vegans would have to wait another century for the advent of digital imaging before they could take pictures with a clear conscience.) Early photographic emulsions were only sensitive to the blue, orthochromatic end of the spectrum. This meant that if the subject was wearing red clothing, this would barely register on the negative, giving strange tones in the resulting black-and-white print. It took until 1906 before

1877 "Zazel" becomes the first human cannonball when she is shot almost 20ft at Westminster Aquarium, London.

1882 The world's first electrically lit Christmas tree is installed in the house of Edison's colleague Edward H. Johnson in New York.

1909 Apache chief Geronimo dies at the age of 80.

"panchromatic" film was developed, which allowed all colors to be recorded.

True, full-color photography was far more problematic. The Scottish physicist James Clerk Maxwell produced a system that created a crude semblance of color (though remarkable to audiences in 1861) with three identical exposures that were projected through red, green, and blue filters. The Lumière brothers, having lost interest in moving pictures, marketed the first effective color film method in 1907. This process, known as "autochrome," used colored grains of potato starch in the emulsion to give impressionistic yet credible pictures. This new technique was immediately pounced on by "naturalistic" photographers such as *Jacques-Henri Lartigue* (1894–1986), who argued that life and color were inseparable.

For some photographers, natural light was neither adequate nor cooperative; exposure times needed to be shortened, or

> **Box of tricks**
>
> Flashbulbs weren't developed until the 1920s. They contained magnesium powder within a glass case and were much safer to use. They also allowed flash to be used in wind or rain, should you wish to do so. Unlike modern electronic flashguns which synchronize instantaneously with the shutter, flashbulbs took a fraction of a second to build up their light. Older cameras often have a setting that allows for this delay. Make sure these are not used with electronic flash.

else the modeling of light and shadow in the picture needed to be more creatively controlled, by the addition of extra light sources. If you didn't mind the likelihood of an explosion or clouds of acrid smoke, magnesium ribbon could be ignited to provide a burst of brilliant light. Not even photographers are this foolhardy, so it came as some relief when flash powder, which provided a safe alternative, was produced in 1887. Until the late 19th century most studios used natural light for photography. The first modern tungsten filament lights were developed in the 1880s, but the irregular electricity supply largely precluded their use until well into the next century.

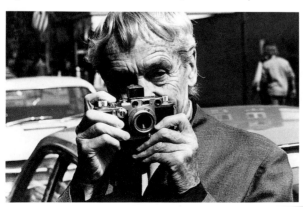

Jacques-Henri Lartigue in the mid 1970s. He studied painting before turning to photography.

1880 Ned Kelly is hanged in Australia. He has robbed two banks, fought the police in homemade armor, and killed three constables.

1881 Barnum and Bailey's circus is created after a merger between two old circus companies.

1883 The Vanderbilts throw a costume party. Mrs V. spends $155,730 on costumes, $11,000 on flowers, and $4,000 on hairdressers.

1880s
You Press the Button, We Do the Rest
Vernacular photography

Practicing the art of the draw.

In the Wild West, your seasoned gunman knew that there wasn't always time to aim before you fired. In a high-noon situation, you shot from the hip. This periodically useful skill became known as a snapshot.

George EASTMAN (1854–1932) was a bank clerk with a keen interest in photography who, in 1880, set up the Eastman Dry Plate Company in New York. He soon realized that for photography to become widely available, and profitable, he would have to devise a system that removed all the cumbersome paraphernalia of developing and printing from the process. Eastman's stroke of genius was to manufacture a

George Eastman: an entrepreneur with an eye for what the public wanted.

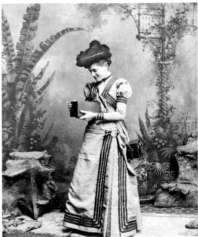

An Edwardian lady gets to grips with her Kodak.

Any amateur could now take satisfactory snaps.

camera with preloaded film, which after exposure was to be returned to the company for all processing. The marketing slogan, "You press the button, we do the rest," became a buzz phrase in polite society, and the "Kodak" brand name came to be used to describe all subsequent cameras of this type.

These first simple box cameras were not truly democratic machines: on their first appearance in 1888, the $25 price tag excluded all but the well-to-do. The lack of any viewfinder made the results a little hit-or-miss, and was the true origin of the

1886 Parquet flooring merchant Samuel C. Johnson introduces Johnson's wax.

1888 Matabele King Lobengula gives away mining rights in Matabeleland and Mashonaland to the Cecil Rhodes interests and agrees to make it a British protectorate.

1889 Van Gogh paints his *Self-Portrait with Bandaged Ear*.

Say cheese!

This magic formula, invoked to suggest a smile but causing a cheesy grin, along with other conventions of family album photography, became established in the early 1900s. Standing stiffly in front of one's house is not a pose born out of modern advertising, but is adopted from the attitudes and practices of the Edwardian middle classes. As affluence spread, you were also expected to stand rigidly in front of the family automobile. Facial expressions tended to be frozen and artificial. There is a moment in every child's life when they make the mental leap between the act of being photographed and the future appearance of a photograph. From this time on, all attempts at natural poses are in vain, as they adopt the conventions of acting up for the camera.

time-honored tradition of cropping the heads off your subject matter.

In this way, the "snapshot" became the accepted term for a whole new genre of photography, as the initial high costs gradually came down and families found themselves in possession of bundles of prints to organize and catalog.

The album became the must-have promotional device for every family, under the watchful eye and the guiding hand of the "husband," who controlled the means of production in the same way that he now hogs the TV remote; the contents were curated by the "wife and mother." The album became a visual manifestation of contentedness and harmony, a trawl through the spreading of the gene pool, as new members were accepted into the family and sometimes mysteriously excised, leaving half-torn pictures with no explanation offered.

Amateur landscape photographers taking the whole business rather seriously (1933).

Box of tricks

Because of the slow nature of the process in these early "brownies," the instructions exhorted the user to "always take the sunny side." Not only did this result in generations being photographed squinting into the sunlight, it also insinuated itself in the collective unconscious: only the "sunnier" activities of family life were deemed suitable for posterity. Vacations, weddings, christenings, and birthdays proliferated in the leather-bound albums; funeral and divorce pictures were less common.

No. 1 Brownie Camera in a pretty box.

1890 New York introduces the electric chair, but executioners bungle the first electrocution on August 7 and newspaper accounts horrify the public.

1896 The U.K. and Zanzibar have the shortest-ever war, which lasts from 9:00am to 9:45am on August 27.

1901 President McKinley is assassinated by a Polish anarchist with a gun concealed under his handkerchief.

1890s~1910

First Impressions
The new photography

We have seen that in the late 1880s the photographic establishment had a bit of an argument, which led to H.P. Robinson, together with Frederick Evans, Frank Sutcliffe, and George Davidson, cofounding the Linked Ring Brotherhood in 1892. This was not an early Olympic confederacy, but rather a closed shop of photographers breaking away from the dictates of the Royal Photographic Society. The initial high-art pretensions of Robinson were evolving toward a more naturalistic approach, but already splinter groups were forming in the ranks.

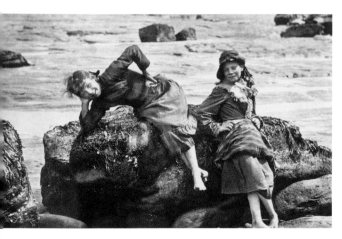

Frank Sutcliffe, "Limpets," 1880: he was known for his pictures of cheery fishing folk in Whitby.

strongly condemned any "tinkering" with the process. The Linked Ring members were united only by a common enemy—the "photo-scientists"—and their love of showing off. They

Some, such as *Robert DEMACHY* (1859–1936), advocated an impressionistic method, using techniques such as gum-bichromate to give a soft, brushlike effect to the print. *Frederick H. EVANS* (1852–1943) was more concerned with the act of "seeing" and the selection of subject, and

were big on "salons," a fanciful term for an exhibition. The Brotherhood's title came from its constitution, which allowed no president or hanging committee (these duties were rotated on a monthly basis), and membership was by invitation only. These were radical times; the philosophies

1906 In Buenos Aires, it is an offense to compliment a woman in the street and culprits are fined 50 pesos.

1909 Frank Lloyd Wright builds the Robie House in Chicago, a classic of Modernist design.

1913 British suffragette Emily Davison throws herself in front of the king's horse at the Derby and dies from her injuries.

of the Linked Ring resonated with those of like mind in Paris, Vienna, and Hamburg, and soon you couldn't move in Europe without falling over a "camera club" or yet another "salon."

Out of this mêlée, a young American studying engineering in Berlin was introduced to photography and the naturalistic movement by his tutor, Dr. Wilhelm Vogel. *Alfred STIEGLITZ* (1864–1946) dropped engineering like a hot rivet and became absorbed in the new photography. By 1891 he had established himself as a serious contender in the European scene. When he returned to New York he found the photographic world still dominated by the precepts of high art. The idea of New York languishing behind Europe was obviously unacceptable, and by 1894 Stieglitz had become the editor of *American Amateur Photographer* magazine. His own photographic work centered on a study of New York street life and is remembered in particular for the "Winter on Fifth Avenue" series.

Stieglitz was not known for his diplomacy: he was asked to leave his magazine editorship because of his habit of insulting readers

> ### IN THE FRAME
> **Charles Baudelaire** *was not a big fan of photography. In his review of the Salon of 1859, he fulminated on the new "art" and the drive towards a technological society. He saw Daguerre as the "messiah" of this new "faith" and mocked society rushing "to gaze at its trivial image on a scrap of metal."*
> **George Bernard Shaw** *had a different perspective: on seeing two portraits of himself at a London exhibition, he remarked that they were superior to the "best" work done with pencil, crayon, or brush—these were hopelessly beaten by the camera.*

who had submitted work for publication that he considered inferior. Later, as editor of the New York Camera Club magazine, he gave space to the early work of Edward Steichen and Clarence White, but was fired for omitting club members' work. His career entered a new phase in 1902, when he formed a group called the Photo-Secession.

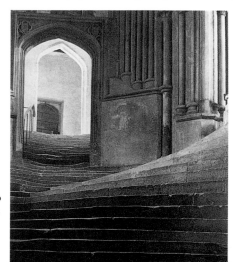

"A Sea of Steps": Frederick Evans's 1903 picture of stairs in Wells Cathedral.

1903 A Russian physicist, Konstantin Tsiolovsky, predicts that man will be able to travel in space and will one day colonize other parts of the solar system.

1907 Peter Behrens designs the first corporate identity for AEG, with a logo to appear on stationery, catalogs, packaging, and products.

1911 The Mona Lisa is stolen from the Louvre, but is recovered in Italy in 1913.

1902~1917

Camera Work
The Photo-Secessionists

Stieglitz telling it like he wants it to be.

Having spent a couple of years alienating the Establishment, in 1902 Stieglitz was given the opportunity to exhibit at the National Arts Club. He spontaneously coined the term "Photo-Secessionists" to give a radical, breakaway slant to the assembled work. This came as a bit of a surprise to the other exhibitors, who hadn't realized they were anything of the sort.

Stieglitz persuaded and cajoled them on board, at first adopting many of the constitutional elements of the Linked Ring, but working with a more liberal attitude about method and style. In contrast to the democratic principles of the Ring, however, Stieglitz ruled with an iron fist, maintaining total control over the work selected for exhibition. In 1903, he established the influential *Camera Work* magazine, and later opened a gallery at 291 Fifth Avenue to promote new photography.

> **MoMA**
> The first director of the Photographic Department at New York's Museum of Modern Art in 1940 was the distinguished historian Beaumont Newhall. He had curated their earlier "100 Years of Photography" show.

The previous year, an ambitious young painter and photographer, *Edward STEICHEN* (1879–1973), had traveled to New York from the creative hotbed of Milwaukee. He sought out Stieglitz, who bought some of his work, and helped him set up the 291 Gallery. Steichen, inevitably, went to Paris and was soon in the thick of the artistic demimonde. He became friends with Auguste Rodin and the photographer

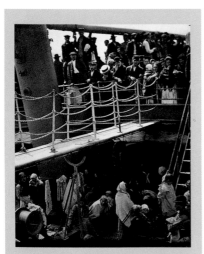

Alfred Stieglitz, "The Steerage," 1907.

1913 King Vidor directs his first movie, *Hurricane in Galveston*. His last will be *Solomon and Sheba* in 1959.

1915 The "vamp" becomes a popular character in movies after Theda Bara appears in *A Fool There Was* drinking her lover's blood.

1917 The Immigration Act in the U.S. bans Asian workers, vagrants, alcoholics, and anyone of immoral purpose.

"The Terminal," Alfred Stieglitz (New York, 1893).

landscape that somehow reflected his inner feelings by a process he called "equivalents." This might seem to us like the "equivalent" of talking to the trees, but it finds an echo in T.S. Eliot's emphasis on the "objective correlative" and predates some of the critiques of photography that would be produced much later in the century.

Stieglitz married the painter Georgia O'Keeffe, produced hundreds of portraits of her, and continued to champion new photographers until his death.

Fred Holland Day, and took pictures of many of the artists of the time, absorbing the soft-edged, impressionistic style into much of his early work.

During the First World War, Steichen worked with aerial reconnaissance photography, where hard-edged detail is of prime concern. This obviously rubbed off on him: after the war he returned to Paris and burned all his fuzzy prewar paintings, while his photography took on the characteristics of his wartime work. In 1923 he was employed as Condé Nast's chief photographer and succeeded in his ambition to become a big cheese.

By 1917 the Secession had become the Establishment, and Stieglitz left center-stage, closing his gallery and magazine and pursuing a more personal line of work, in which he sought symbolic values in the

IN THE FRAME

Frederick Holland Day *(1864–1933) was closely identified with the pictorial movement, both in the U.S. and Europe. There was an undercurrent of homoeroticism in his work, but he is most remembered for the criticism he attracted for his series of crucifixion pictures created on a hill outside Boston in 1898.*

1917~1970s

Strange Conjunctions
Dada and Surrealism

The idea of secession was not invented by Stieglitz. In the early 20th century you couldn't take a sideways step in Paris without knocking over a radical, "modern" artist. The avant-garde was everywhere, and "-isms" abounded. Photography had to some extent liberated the painter from the shackles of representation, and reciprocally the new thinking in art fed back into the work of photographers. The distinctions between painting and photography began to break down.

> **IN THE FRAME**
>
> *The work of American photographer* **William Wegman** *(b. 1943) brings together a modern approach to the surreal with a gratifying sense of the whimsical. He is probably best known for his series of images of his pet Weimaraner dogs, named Man Ray and Fay Wray. He put them through endless embarrassments, yet the resulting pictures succeed in exploring themes of death, solitude, and art itself. Top dog photographer, though, has to be the wonderfully fanciful Elliott Erwitt (see page 85).*

Heads will roll
During the Second World War, British photographer Angus McBean served two and a half years in prison after one of his surreal images, of the disembodied head of actress Diana Churchill under a kitchen chair, was picked up by the Nazis and used for propaganda purposes in the mistaken belief that she was Winston's daughter.

A.L. COBURN (1882–1966) exhibited a series of images called "New York from its Pinnacles," looking down from high buildings and rendering the cityscape in geometric and abstract forms. Then, in 1913, the "Armory" show came to New York, amazing and outraging in equal measure as the American public experienced the avant-garde. Among the exhibitors was Marcel Duchamp, whose "Nude Descending a Staircase" combined

Alvin Langdon Coburn, "Octopus," New York, 1912.

1941 Aerc insect sprays go on sale in the U.S.

1956 The 27-ton Rolls-Royce camera is commissioned. It is 8ft 11in high, 8ft 3in wide, and 45ft 11in long and the f/16 Cooke Apochromatic lens measures 64 inches.

1972 Underwater photos taken in Loch Ness show a long flipperlike structure attached to a much larger body, similar to the extinct plesiosaur.

McBean takes Diana Churchill's head.

elements of Cubism, Futurism, and a homage to the multiple-image work of Marey, and who was destined to become one of the founder-members of the Dadaist movement. In 1916, Dada grew from a loose collaboration of artists in New York (Duchamp and Man Ray), Paris (Max Ernst and Jean Arp), Berlin (Hannah Höch, John Heartfield, Otto Dix, and George Grosz), and Zurich (Tristan Tzara and Christian Schad), who shared the same antiart and anti-establishment vision. They believed in chance events, in destruction, outrage, and the "death" of beauty. In fact, they were the sort of people who would be charged a very high premium on their car insurance.

Schad's experiments concerned the positioning of objects and paper cutouts directly onto photographic paper. Later, in 1921, Man Ray, with his assistant Lee Miller, used a variety of photographic processes to produce "Rayograms" and solarized (partly fogged) images.

The Surrealists, who were basically the Dadaists grown up a bit, were interested in the unconscious mind as a creative tool, and were influenced by the writings of Freud and Jung. A basic Surrealist device was to bring together within the frame strange conjunctions of objects and events.

Photography and film lent themselves wholeheartedly to this aim. The strange conjunction and the dreamlike image became a subgenre in itself, appearing in the work of Bill Brandt (a student of Man Ray), Angus McBean, Winifred Casson, and André Kertész (*see page 80*), and more recently, Jerry Uelsmann and Duane Michals (*see page 122*).

Rayogram by Man Ray, 1927.

Box of tricks

Rayograms (or photograms) are created in the darkroom by shining light through objects onto photographic paper, then developing the result to give abstract pictures. Solarized pictures are created by exposing the image to a flash of light during development to produce a strikingly dark contour. Man Ray and Lee Miller played around with these processes, creating images of hands, breasts, and other body parts—just as bored office workers nowadays get a kick out of photocopying their body parts.

1920 Harry Burt creates the Good Humor, a chocolate-covered ice-cream bar on a stick.

1921 The phrase "cold turkey" comes into use to mean abrupt withdrawal from drug addiction.

1923 P.G. Wodehouse writes *Very Good, Jeeves*, starring Bertie Wooster and his butler Jeeves.

1920s

New Objectivity in Germany
Closeups of the ordinary

Getting to grips with an egg and spoon.

One of the techniques adopted by the Surrealists to shock people into a "new" vision was to photograph or paint the everyday in extreme closeup, using the camera to bring a new context to the subject. This fresh look at the familiar and everyday was also being explored by the wave of "New Realist" or "straight" photographers who were establishing a foothold on both sides of the Atlantic.

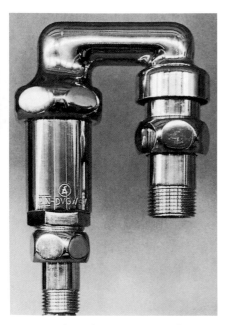

"Pipe Air-Release Valve" by Albert Renger-Patzsch (1961). Especially useful for plumbers.

In Germany, this movement was known as "Neue Sachlichkeit" ("New Objectivity"), and it grew out of a reaction against Impressionism. This new vision believed that the subject itself was of primary importance, and that the photographer's role was that of selection and "accurate" representation of the subject. The everyday household implements, machine parts, architectural details, people, and whatever else, had intrinsic

Box of tricks

Photography is about making choices, often making compromises: choices about film, camera, light, viewpoint, moment, composition, and meaning. Inside the photographer's head, millions of small decisions buzz around prior to the making of the image. Most of these are influenced by what the photographer wants to say about the subject and, secondly, to whom he or she is saying it. What will their eventual audience bring, in terms of perceptions and preconceptions, to the process of viewing the work? "Objectivity" as a concept within photography, like everything else, has to be treated cautiously.

1926 Herbert Bayer designs the Universal sans serif typeface because he's sick of type that tries to imitate handwriting.

1928 Max Ernst paints a picture of Mary spanking the baby Jesus.

1929 Leon Trotsky is exiled to Siberia along with 1,600 of his followers.

"beauty" and worth. The photographer invested them with significance and used a minimalist technique so as not to "intrude" upon the process. The main protagonists of this movement were *Albert Renger-Patzsch* (1897–1966), who published a hundred such images of ordinary housing and industrial sites in *The World Is Beautiful* in 1928, and *Karl Blossfeldt* (1865–1932), whose *Art Forms in Nature*, featuring closeup pictures of ferns, flowers, and seed pods, was published in 1929.

This work met with hostility from both aging Pictorialists and new photojournalists for being either soulless or somehow presumptuous: how dare these individuals decide what is significant? But selection lies at the core of the photographer's art: what to take and why are fundamental issues. Now, frankly, a fern is a fern is a fern; looking at it closely doesn't really change that. The difficulties arise from the notion of objectivity itself. Both Renger-Patzsch and Blossfeldt brought a modernist, minimalist, design-oriented ideology to the process of selection, composition, and production. There is a lack of passion in the work, a deliberate distancing of the photographer from the subject and depersonalizing of the results. Invested with meaning, they become meaningless, merely aesthetic. If the mundane becomes valuable through composition, everything is then of equal worth. Photographers find themselves applying technique without critique.

Antischmaltz

Neue Sachlichkeit was a reaction against the sentimentality and romanticism that pervaded much art of the time. The new objectivity was also encompassed by filmmakers, as exemplified by the realism of Eisenstein's *Battleship Potemkin* (1925).

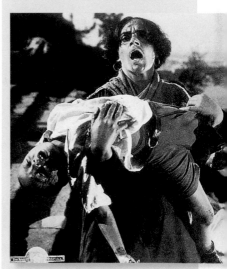

A scene from *Battleship Potemkin*: the massacre on the Odessa Steps, complete with blood and guts.

COMMERCIAL STYLE

The style and precepts of this new objectivity found an outlet, somewhat ironically, in the graphic arts and advertising, where its clinical minimalism found favor among a new generation of "creatives." During the 1930s a new wave of cool and stylish advertising mirrored the modernist movements in interior and product design: outlines became cleaner and typography less fancy.

1922 Charles Osborne of Iowa begins hiccuping and doesn't stop till 1990.

1923 France and Belgium occupy the Ruhr Valley in protest of Germany's failure to keep up with war reparation payments.

1924 Norman Bel Geddes transforms New York's Century Theater into a Gothic Cathedral for a production of Max Reinhardt's *The Miracle*.

Box of tricks

The zone system is a method of matching the contrast range in the subject—from the darkest to the lightest areas—with the ability of black-and-white film and printing paper to reproduce these. The zone system divides the contrast of the subject from deepest black to white in a series of ten gradations or "zones." Most films could only record detail in at most seven zones, so Ansel Adams devised an exposure system that allowed the maximum relevant detail to be recorded.

Matching the zones.

1920s
Who Ate My Pepper?
New Realism in the U.S.

In 1922, Edward WESTON (1886–1958) left his California studio and traveled to New York to meet Paul Strand and Alfred Stieglitz. Whatever they said to him had a profound impact, because shortly afterward Weston abandoned his lucrative studio and his soft-focus romantic photography and traveled to New Mexico, where he set up house with the artist Tina Modotti and became a bohemian.

The final issues of *Camera Work* had featured the images of *Paul STRAND* (1890–1976), a newcomer on the scene who, like most photographers of the time, had dabbled with Pictorialism, but was now developing a new, direct style. Strand was in fact reevaluating the medium of photography and looking to sever its apron strings with painting. For him, the limitations of photography were also its strengths, and developing a mastery of technique was more important than attempting to ape the qualities of other media through artful manipulation. During this phase of his career, Strand's work was noted for its use of strong geometric composition; later he would turn to a more documentary, humanistic style. In many ways Strand was

Careful geometric composition: "The White Fence, Port Kent, New York, 1916" by Paul Strand.

1926 Walter Dorwin Teague invents the Kodak "Baby Brownie," a simple, functional camera aimed at the youth market.

1928 Margaret Mead writes *Coming of Age in Samoa.*

1930 Sliced bread is introduced. Consumers are suspicious at first because it goes stale more quickly than nonsliced.

an idealist, believing in the essential nobility of man (he was obviously not a student of history). Having taken these notions on board while studying at the Ethical Culture School under Lewis Hine, Strand incorporated his socialist beliefs into his work. He left the U.S. for Europe in disgust at the antics of McCarthy's Un-American Activities Committee.

F/64

Weston, too, had strong views about photography. He felt that the finished print should be previsualized through a contemplation of the subject, and that photographers should have a special way of seeing the world around them. This philosophy might have taken shape at the start of his career when he was so broke he couldn't afford to waste film or paper.

In 1932, he formed Group f/64, with Ansel Adams and Imogen Cunningham ("f/64" was the smallest available aperture on their cameras, and gave the greatest depth of field or range of sharp focus to a picture). As Weston liked to work alone, forming a group was probably a mistake. This short-lived union espoused "straight photographic thought and production" and became a rallying point for like-minded photographers.

Eye, eye
The human eye is much more sensitive to discerning detail in extremes of light and shade than any black-and-white film. To get an impression of how the film "sees," try squinting.

The most famous pepper in the history of photography (and possibly horticulture).

Edward Weston's 1930 picture is entitled "Pepper No. 30."

Weston's range of work covered the Taos countryside, the desert, lots of cacti, nudes, and an assortment of fruit and vegetables, including what has to be the most famous pepper in history. Adams worked mainly with landscape, often following in the wagon tracks of Watkins and O'Sullivan. Having a wizardry of technique, Adams devised the "zone system," a method of exposure and development control that gave precise results for the finished print, again following Weston's philosophy of previsualizing the final photograph.

1918 Kasimir Malevich paints his Suprematist composition *White on White*, a single-color canvas intended to be the abstract to end all abstracts.

1920 Igor Stravinsky moves to Paris and writes his *Symphonies of Wind Instruments*.

1921 Three million die in a famine in Russia and corpses are piled 20ft high in the streets of Moscow because the ground is frozen too hard to dig graves for them.

1917~1920s

Modern or What?
The Russian Revolution

Alexander RODCHENKO (1891–1956) was modern to his boots. He wouldn't take a picture unless he could find some new, wacky angle. Starting as a painter and graphic designer within the Russian Constructivist movement, Rodchenko had little

Rodchenko believed in suffering for his art.

respect for traditional viewpoints, both metaphorically and literally. Referring to the common use of the waist-level viewfinder, he called all such images "belly-button shots." No, everything had to be taken from above or below, or anywhere else but in front of. He'd rather shin up a lamppost than take a traditional picture. Failing any novel vantage point, he'd make do with positioning the camera with the lens peering up the nostril of the nearest subject.

The Constructivists shared some philosophies with the Italian Futurists—a rejection of traditional art values and a belief in the culture of the machine age. Rodchenko, together with other Constructivists El Lissitzky and Vladimir Tatlin, believed in a utopian vision of man and city as a machine— somewhat incongruously in a largely rural nation like Russia. The photograph, like film, was seen as new and technical, highly appropriate to the machine age.

After the October Revolution, Rodchenko became a major figure in the avant-garde, teaching and contributing to documentary and propaganda films and publications. His typically low-angle images were regularly seen in the

"The Constructor" by El Lissitzky,1924. The creator's hand draws a circle which forms a halo symbolizing the designer's then godlike potential in the USSR.

1924 Petrograd is renamed Leningrad in honor of the Soviet leader who died this year. (In 1991 it reverts to its original name of St. Petersburg.)

1927 Twenty alleged British spies are executed in Moscow.

1929 Mayakovsky satirizes the Soviet state in his 1929 play *The Bedbug*.

Constructivist magazine *Lef*, and his photomontages notably used to illustrate *Pro Eta*, poems by Vladimir Mayakovsky. The Constructivist style also permeated Russian film: similar camera angles and the use of montage can be seen in the films of Sergei Eisenstein and Dziga Vertov.

Eventually all this fun had to stop. Stalin had slightly different views on art from the Constructivists. He wanted uplifting images of big, strapping workers staring into the future with pickaxes over their shoulders. Social realism meant that monumental, slab-cheeked folk with flags became the order of the day and, really, you didn't want to get on the wrong side of Stalin. Rodchenko found himself photographing the massive works programs of the early 1930s, published in *USSR in Construction*, including the

Uncle Joe says
Like much of Russia's Revolutionary art—described by Stalin as "new-fangled" and therefore "bad"—Rodchenko's work was only rediscovered by the West in the middle of the 1950s.

Rodchenko: a photomontage for Mayakovsky's *Pro Eta* (1923).

oppressive conditions of the "Baltic Sea Canal." He eventually saw the writing on the wall, and gave up photography, concentrating instead on book production.

IN THE FRAME

The Italian Futurists were fervent advocates of the machine age: anything that went fast or was made out of metal really turned them on. **Giacomo Balla (1871–1958),** *one of the Futurists' leading lights, made paintings of dogs with their little legs all a blur, or of cars with spinning wheels to suggest speed and movement. He also used to take part in Futurist "happenings," performing nonsense plays as a character called Monsieur Putipu while wearing a multi-colored pot on his head. Those Futurists!*

1920s~1930s

Mixing Their Media

The Bauhaus

The Bauhaus ("Building House") was an all-singing, all-dancing, multi-media sort of place. Taking the ideas of the Futurists and Constructivists, the Bauhaus attempted to meld all these diverse elements into a new type of art-school education. Elsewhere, the Arts and Crafts movement, classical Rome, and the Renaissance were the main areas of study, but the Bauhaus was about steel and plastic, new architecture unifying all the arts, and exploring the machine culture. Established by Walter Gropius in Weimar in 1919, the Bauhaus set out to synthesize the worlds of art and design.

Herbert Bayer's dramatic photomontage entitled "Lonesome Big City Dweller" (1932).

In 1923, *László* MOHOLY-NAGY (1895–1946), a convert to Dada and Constructivism, was appointed as Gropius's deputy. But the Bauhaus was in a state of constant tension with the notion of authority, owing to its unconventional structure and left-wing politics. It was compelled to move from its Weimar base in 1924 by a right-wing local government, and relocated to Dessau. In 1933, with the accession of the Nazis, it was forced to close, opening in Berlin as a private school, but when Hitler took power the Bauhaus as a German institution was effectively finished. Moholy-Nagy reopened a version of the Bauhaus in Chicago in 1937.

1930 Dashiell Hammett writes *The Maltese Falcon* about cynical detective Sam Spade. Humphrey Bogart will play the role in the 1941 movie.

1933 The Nazis close down the Bauhaus design school in Weimar.

1938 Supermarket shopping carts are introduced in Oklahoma.

Moholy-Nagy and Walter Gropius in the Bauhaus building.

Moholy-Nagy encouraged experimentation, working extensively with montage, multiple printing, composition, and the use of text. Peterhans leaned more toward still life and precision. Hitherto strictly scientific usages of photography, such as X rays and photomicrography, were incorporated into this new aesthetic. Relationships between the concerns of the Bauhaus abstract painters Paul Klee and Wassily Kandinsky, and Moholy-Nagy's photographic work, became ever closer. Again the aerial viewpoint, reducing the ground to shape, texture, and form, became a common theme. The nomadic lifestyle, with its constant upheaval, was deeply frustrating and stressful for the staff, but this did not prevent the Bauhaus from becoming one of the most influential artistic schools of thought of the 20th century.

X rays

X-ray photography was invented by Wilhelm Röntgen (1845–1943) in 1895, using his wife's hand as the subject. Everyone got very excited and they gave him the first Nobel Prize in physics in 1901. The first complete X ray of a human body was made a year later. X-ray photography became very popular with artists and public alike. Judging by the way your dentist scoots off down the corridor whenever your teeth are being X rayed, it's been noticed in the intervening years that the stuff is dangerous.

MIX AND MATCH

The multidisciplinary vision of the Bauhaus allowed for experimentation and cross-fertilization between differing art forms; old territorial divides between crafts, engineering, graphic design, fine art, music, and performance were swept aside. These people would try anything as long as it was "modern."

The arrival at the Bauhaus of Moholy-Nagy and his wife, Lucia, together with Herbert Bayer and Walter Peterhans, brought photography into greater prominence.

Box of tricks

Photomicrographs—images taken through standard or electron microscopes—date back to the 1850s, but it was only after the invention of the electron microscope (which can magnify objects up to a million times) in the 1930s that we began to see details of the world at molecular level and realize what all our funky little body parts are really up to.

1878 Cleopatra's Needle is erected in London, weighing 189.35 tons.

1897 George Matthew Schilling begins a walk around the world, a feat he will finish in 1904.

1905 Picasso paints *Les Noces de Pierrette*. In 1989 it will sell for 315 million French francs (over $51 million).

1870s~1930s

Photography as "Evidence"
Obsessive measures

The Victorians loved to classify things, to line them up and count them—as if by measuring everything, they would know everything. Psychologists, anthropologists, and criminologists lined up to use the photograph as evidence to support their theories. Photography appeared to give an "assurance of truth"—it could be presented as "factual" support for all sorts of outlandish nonsense. Remember, this was a time when some people believed that the bumps on your head provided an insight into personality, and those phrenology heads weren't originally sold for their decorative value. By the mid-19th century, bodies of photographic work "illustrating" the physical characteristics of the mad, the criminal, and the poor, began to percolate into the public domain.

An 1862 photo for Darwin's *Expressions of Emotion in Man and Animals*.

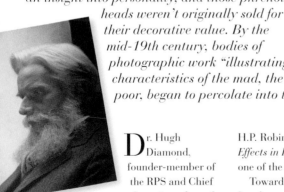

Havelock Ellis's views scandalized contemporaries.

Dr. Hugh Diamond, founder-member of the RPS and Chief Superintendent of the female wing of the Surrey Lunatic Asylum, not only published but also exhibited studies of his patients. These pictures became "collectable," and

H.P. Robinson dedicated his *Pictorial Effects in Photography* to Diamond as one of the fathers of photography!

Toward the end of the century Cesare Lombroso published *Criminal Man*, another attempt to type the physiognomy and "demonstrate" the difference in appearance between the "normal" citizen and the corrupt. *Havelock ELLIS* (1859–1939) took these ideas to heart in his

1912 Frieda Weekley causes a scandal in Britain by leaving her husband and three children to run off with D.H. Lawrence.

1923 Edward Weston photographs Tina Modotti naked on the terrace of their house in Mexico.

1938 The Indianapolis police use the first "drunkometer" to measure the amount of alcohol a person has drunk.

unfortunately influential work. *The Criminal*. Even *Oscar REJLANDER* (1813–75) got in on the act when he produced Darwin's *Expressions of Emotion in Man and Animals* in 1872.

But it was with a cousin of Charles Darwin, *Francis GALTON* (1822–1911), an obsessive quantifier, that the truly dangerous possibilities of this intellectual cul-de-sac began to emerge. Galton brewed a heady mélange of Darwinism, class superiority, racial stereotype, and downright confused thinking. He believed that physical appearance alone, evidenced by the photographic image, could be utilized to validate his theory of eugenics—a bastardized version of evolution that purported to show a hierarchy of inherited personality, intelligence, and racial characteristics.

mug shots

While Galton was fooling around with eugenics, Alphonse Bertillon (1853–1914), chief criminal investigator for Paris, was designing a system to record a criminal's identity. In 1882 he devised the forerunner of the mug shot, establishing the principles of recording identity that would embarrass Hugh Grant, among others, over a century later.

Galton considered his most successful body of work to be *The Jewish Type*, published in 1883. We begin to see where all this might lead. And while we can't blame Galton for future events, the history of persecution of the Jews should have given him pause for thought. The work of typologists like Galton eventually would provide a perverse "justification" for the actions of the National Socialists.

IN THE FRAME

Doctor Barnardo, *founder of homes for poor and destitute boys in England in the mid-19th century, used photography to record the appearance of the boys on arrival and eventual departure from the homes to demonstrate the marked improvements during their stay. Sets of these pictures were collected widely by the sentimental Victorian public.*

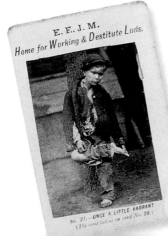

One of Barnardo's children before and after his stay in one of the famous Doctor's homes.

1931 Martha Graham choreographs *Primitive Mysteries* with simple staccato movements, using black-and-white sets and costumes.

1932 In France, Pierre Fresnay begins sending flowers to Yvonne Printemps and will continue to send them every day for 42 years.

1934 Heinrich Himmler is appointed head of the German concentration camps.

1930s
Photography Fights Back
The growth of Fascism

Most of the time, one plus one equals two. For the Dadaists and Surrealists, who were dealing with a new visual language, the combination of two disparate elements created a third, new meaning. Photomontage—the cutting and pasting of pictures and text within the frame, or the multiple printing of images in the darkroom—lent itself to this new thinking. If you have a picture of a cuddly toy, it sends out one set of meanings. Combine this with another, fresh image—of a crashed aircraft, perhaps—and a new reading presents itself.

"Let the Dada kitchen knife cut through the final beer-belly culture of Weimar Germany": Hannah Höch (1919–20).

It became obvious to *John HEARTFIELD* (1891–1968) and *Hannah HÖCH* (1889–1979), members of the Dada movement, that photomontage offered a much more direct way to communicate to a wider audience than the media of the usual fine-art cognoscenti. In montage, Heartfield found an ideal form to promote his socialist ideas and to draw attention to the rise of

Cutting and pasting
To create your own montages, cut around the images with a craft knife, holding the blade at a 45-degree angle to achieve a more "seamless" edge when you glue them down. Try to use "single-weight" or thin paper originals.

Fascism in Germany during the 1920s and early 1930s. He felt that the Great Depression was largely the result of capitalism and that Hitler was being covertly supported by the major industrialists of the time. Montage became a political weapon; using the Berlin-based *Arbeiter Illustrierte Zeitung*, or *AIZ*, Heartfield published a series of images attacking

1936 Sunglasses with Polaroid lenses are introduced by Land-Wheelright Corp.

1937 The Hungarian-born U.S. architect Marcel Breuer designs the S-shaped chair, to complement his architectural designs.

Hitler and his supporters. "Adolf the Superman" shows Hitler with a gullet and gut full of money; "Brotherhood of Murderers" and "Madrid—1936" illustrate the growing ties of blood between the evolving Fascist dictatorships of the mid-1930s. "Hurrah, the butter has all gone" shows a family sitting at the dinner table tucking into a meal of bullets and ammunition. Memorably, it is a cover from *AIZ* in 1932. "The Meaning of Geneva," depicting the dove of peace impaled upon a bayonet, that presages what is to come.

The Nazis were not known for their self-deprecating sense of humor. This tirade of lampoonery and criticism could not last. Heartfield wisely left Germany in the early 1930s to continue his work in Prague and for *Lilliput* magazine in London.

Abandoned

John Heartfield's father, Franz Herzfeld, was a poet and political activist who was once jailed for a year for blasphemy. His propensity for getting into trouble with the authorities meant that his family always seemed to be on the run. In 1898 they settled in an isolated mountain hut near Salzburg, but during that year the parents disappeared without trace, leaving John and his siblings to be raised by the local Burgomeister.

Box of tricks

Photographic printing paper comes in a variety of thicknesses (weights), forms, and finishes. Originally all paper was "fiber-based," meaning that it was made from high-quality paper on which the emulsion was coated. This presented problems with processing and drying. Nowadays you have the choice of "resin-coated" paper, which contains layers of plastic to speed up the process and introduce stability into the print. For traditional montage, the fiber-based option is preferable.

IN THE FRAME

Photomontage as a political tool was reinvented by a British photographer, **Peter Kennard,** *in the 1980s. He brought a socialist perspective to the policies and actions of the Thatcher government, dealing with issues as diverse as the Falklands War, the siting of Cruise missiles on U.K. soil, the poll tax and, most memorably, Thatcher's vision of herself as the new Victoria.*

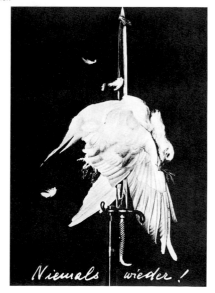

John Heartfield's 1932 photomontage "The Meaning of Geneva" was a shocking symbol, eerily predicting the Second World War.

1924 Barbara Cartland writes *Jigsaw*, her first successful novel, about a young innocent named Mona wandering the streets of London until she finds a duke to marry her.

1927 President Charles B.D. King of Liberia claims to have won the elections with a majority of 234,000. Some are suspicious as this amounts to 15½ times the entire electorate.

1940 Welsh singer Tessie O'Shea has a hit with the song "I Fell in Love With an Airman Who Had Big Blue Eyes, But I'm Nobody's Sweetheart Now."

1920s~1950s
All Human Life is Thereish
The picture spread and the photo story

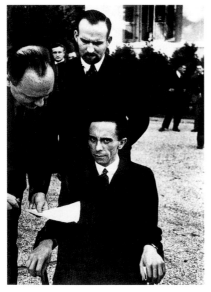

In 1933, when Eisenstaedt took this picture, Goebbels was made Hitler's "minister for propaganda and national enlightenment," i.e. manipulator of the media.

In the mid-1920s Germany saw a rapid growth in the number of picture magazines. Unlike newspapers, which used photographs to illustrate the news, these published photo-essays that allowed the photographer to probe deeper into a story. This became known as "human-interest" photography, and its perpetrators, photo-journalists.

Box of tricks

The Ermanox 6 x 9cm plate camera, manufactured in 1925, could accommodate shutter speeds of up to one thousandth of a second to freeze movement. This was combined with a very fast lens, as a wide lens aperture allows more light onto the film, making available-light photography more accessible.

The new 35mm roll film, combined with lightweight cameras such as the Ermanox and the Leica, gave photographers more freedom to move inconspicuously among their subjects and to mastermind less formal and more spontaneous images. Prior to this, politicians, celebrities, and statesmen had time to prepare their public faces as photographers laboriously set up equipment; now they could be "caught" unawares, and an unguarded expression or gesture could be immortalized for a mocking public. A classic example is Alfred Eisenstaedt's picture of arch-propagandist Joseph Goebbels, taken in 1933. Goebbels, seated, looks up and realizes too late that he is being "snapped." His anger is writ large on his face—this is not the image he wants.

1947 A movie called *Bill and Coo* stars two love birds and is filmed in a model village.

1951 The first soap opera, called *Search for Tomorrow*, begins on U.S. television.

1958 Worldwide, 25 million Hula-Hoops are sold.

Picture Post covers often had a strong influence on British public opinion during the war years.

The mags

Lorant established *Lilliput* magazine in Britain, later becoming the editor of *Picture Post*. Until its demise in the 1950s, *Picture Post* commissioned many of the leading photojournalists of the time, including Tim Gidal, Bill Brandt, Bert Hardy, Thurston Hopkins, and Grace Robertson. In France, *Vu* magazine, founded in 1928 by Lucien Vogel, hired Henri Cartier-Bresson, Brassaï, and Robert Capa and later, in 1936, Henry Luce launched what was for many the ultimate photo-essay journal, *Life*, employing Margaret Bourke-White, Alfred Eisenstaedt, W. Eugene Smith, and Carl Mydans.

Erich Saloman, André Kertész, Tim Gidal, and Felix Man all worked for Stefan Lorant, the talented picture editor at the *Illustrated Press*, and between them they established the ground rules for the photo-essay. Lorant would brief the photographers, who would have control over the production of the images, but once the films were returned to Lorant, he would have the final say on selection and layout. These relationships between

IN THE FRAME

Oscar Barnack, *a designer for the German microscope manufacturers Leitz, constructed the Leica Camera in the mid-1920s. The true potential of this machine was not fully realized until the late 1930s, when 35mm film became sufficiently improved to give high-quality enlargements. Its compact shape and cheaper price then made it popular with amateurs and pros alike.*

photographer and editor became standard until after the Second World War.

Many of the photographers and editors fled Germany in the early 1930s with the rise of Fascism. Some, wisely, went to the U.S., Switzerland, or, like Lorant, to the U.K. Others, who were less fortunate, went to France or Hungary and were swept up in the coming holocaust.

The traditional relationship between photographer and editor continued until the end of the Second World War, when many photographers wanted to have more control over the editing and publication of their work. Although there had previously been picture and press agencies that commissioned work, the new spirit of the time called for photographers' or workers' cooperatives.

1922 Valentino makes women swoon when he plays a seductive matador in *Blood and Sand*.

1927 On Long Island, Ruth Snyder and Henry Judd Gray are convicted of killing Ruth's husband Albert with a sashweight.

1928 Herbert Hoover is elected president after promising a chicken in every pot and a car in every garage.

1920s~1930s

Snap Out of It
The Depression years

On October 28, 1929, the U.S. went belly-up. The stock market, which had seen a period of uncontrolled growth and greed, threw itself off a high building. An epidemic of panic swept the country; savings evaporated, unemployment exploded, and businesses folded; it was the sort of dynamic economy President Herbert Hoover could have done without.

Ben Shahn, "Levee Workers": farmworkers during the Great Depression.

Particularly hard-hit were the share-croppers and farmers of the Midwest. After years of official advice telling them to rip up vegetation and produce vast acres of unprotected crops, many of them had already seen their topsoil blown into the next state, and were struggling against wind and drought. Having their loans and mortgages called in was just the icing on the cake. Some attempted to pack up and travel to the promised land of California to pick those grapes of wrath. Others stayed and plunged further into poverty.

On the Net
The vast collection of negatives and prints from the Farm Security Administration are currently held in the Library of Congress archives. Many of these are available to view on the Library's web site (http://www.loc.gov).

By 1932, the U.S. had given up on Hoover's failed attempts at a remedy, and elected Franklin Roosevelt with his promise of a "New Deal." As part of this, Roosevelt had established the Resettlement Administration in 1935, to bring training, low-interest loans, and farm camps to the migrant population. In 1937, this was renamed the Farm Security Administration (FSA). An economics graduate by the name of Roy Stryker was brought in to run the Historical Section, with a brief to document America's recovery. Stryker, as a poor student in New York, had attended

Modeling blues
In 1978, the original subject of "Migrant Mother," Florence Thompson, was tracked down to a trailer park in California. Becoming a cultural icon had done little for Florence's quality of life: she observed that it had "done her no good."

1930 William van Alen builds the Chrysler Building in New York, with its stylized metal sunburst on top and the chevron patterns of the Chrysler logo.

1935 Elsa Schiaparelli designs hats that resemble shoes, bags with telephone handles, aspirin necklaces, and trompe l'oeil sweaters.

1938 In Washington D.C., a minimum wage is set for workers—25 cents an hour.

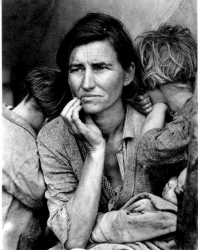

the public lectures of Lewis Hine and Jacob Riis, and had been left with a sense of the power of a strong photographic record.

Between 1935 and 1943, when America's attention moved elsewhere, Stryker hired many diverse photographers, producing an archive of over a quarter of a million images. Among these were *Arthur ROTHSTEIN* (1915–85), who was responsible for the memorable "Fleeing a Dust Storm" in 1936, but met his own storm of disapproval from the purists when he rephotographed a cow skull in more compositionally effective surroundings. This was obviously not "documentary." Stryker also employed *Walker EVANS* (1903–75), a doyen of American photography, who brought a contemplative and considered vision to the task. Evans collaborated with writer James Agee to produce a classic text, *Let Us Now Praise Famous Men*, a study of tenant farmers that was five years in the making.

Lange found Florence Thompson, the subject for "Migrant Mother," living in a lean-to tent with her children; their diet consisted solely of vegetables.

LANGE VS. STRYKER

Dorothea LANGE (1895–1965) brought a different intensity to her work, a tenacity and stubbornness that would eventually lead to a parting of ways with Stryker. She resisted all his attempts to acquire her negatives (a contractual arrangement), because she wanted to exhibit them. She hoped that by employing Adams (*see page 98*) to develop and print her work she would placate Stryker, and she knew that he thought her "Migrant Mother" (1936) to be *the* image of the FSA. Ben Shahn, a friend of Evans, and Russell Lee both made huge contributions to the archive. Stryker finally selected 200 images for *This Proud Land* (1972), a publication that for him summed up the spirit of the FSA.

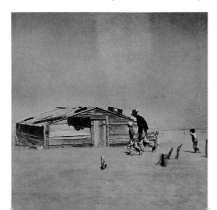

Arthur Rothstein, "Fleeing a Dust Storm," 1936, commissioned by the FSA.

1922 The first issue of *Reader's Digest* appears, containing "factual articles of enduring value and interest," including "How to Stay Mentally Young" and "Love: Luxury or Necessity?".

1926 Moroccan tribesmen tie up a French mail pilot who has landed his plane after engine trouble and ransom him for 1,000 pesetas.

1930 Luis Buñuel's *L'Age d'Or* depicts Jesus and the Marquis de Sade together.

1920s~1930s

Looking at Folk
Mass observation: Sander and Spender

The idea of the photo-essay, a comprehensive body of documentary or reportage photographs centered around one idea, really took hold in the 20th century. Posterity becomes a big issue. As such work takes on a patina of age, it gains added worth as a historical document, and can also become "art." Photographers began to picture their time with an eye to the future.

In 1910, *August Sander* (1876–1964), a portrait photographer, had a rather ambitious idea—he wanted to photograph every type of person in Germany. Sander believed in a "sociological arc," from high to low, which would enable him to create a "true" picture of "Man in 20th-Century Germany." He published the first batch of these pictures, *Face of Our Time*, in 1929, followed by *German Land, German People* in 1934. Unfortunately, Sander had been at the back of the line when luck was handed out. He had been working away for over a decade, demonstrating how diverse the population of Germany was, when up popped the Nazi Party with a slightly different vision. His books were destroyed and his negatives seized by the inappropriately named Ministry of Culture. Sander decided to play it safe and turned his camera to landscape. Quietly, however, he recommenced his original work, except that his studio was bombed and his negatives later destroyed by looters. Determinedly, Sander soldiered on and received international recognition.

August Sander's "Young Farmers in their Sunday Best," 1914, published in *Face of Our Time*.

1932 Betty Boop is created by Max and Dave Fleischer, with a short black dress and sexy, swaying walk.

1934 George Carwardine designs the anglepoise lamp, which uses hinges to mimic the human elbow joint.

1939 In Britain, over a million children are evacuated from towns to the countryside for fear of German bombs.

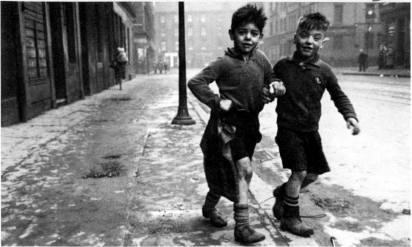

MASS OBSERVATION

Bill Brandt (1904–83) was a student of Man Ray, who infected him with a dose of Surrealism that Brandt never managed to shake off. He worked throughout the 1930s on projects that documented the Depression in northern England before exploring middle- and upper-class life. He infused his pictures with a harsh contrast and a sense of the "strange." After the war, the surreal gene in Brandt's work took hold and he produced a memorable body of work that included portraits of writers and artists, and nudes taken with a cheap, distorting, wide-angle lens.

In the mid-1930s the Mass Observation organization attempted to create an anthropological survey of British life, based on the somewhat misguided premise that the discovery of national identity would be the first step toward curing society's ills.

Bert Hardy's well-known image of two boys in the impoverished Gorbals district of Glasgow, 1948.

IN THE FRAME

*Among the photographers who worked for Mass Observation were **Bert Hardy** (b. 1913) and **Humphrey Spender** (b. 1910). Their mission, should they choose to accept it, was to move "invisibly" through working-class lives, and to record "objectively" and "dispassionately." As the photographers themselves observed, the presence of the camera inevitably alters the behavior of the subjects, and though aiming to "help" them, ends up exploiting them. There are direct comparisons with so-called "fly-on-the-wall" documentary making.*

1930 Violinist Yehudi Menuhin, aged thirteen, plays to a crowd of 5,000 at Royal Albert Hall, in London.

1932 Johnny Weissmuller and Maureen O'Sullivan star in the first "Tarzan" movie, *Tarzan of the Apes*.

1933 Henry Beck draws the classic map of the London Underground using the principles of electrical circuit diagrams.

1930s

Au Naturel

The decisive moment?

Box of tricks

Here's a tip if you want that "uncropped" look but have inadvertently got a telegraph pole or something unwanted on the edge of your negative. Frame the picture as you want it in your enlarger. Cut a piece of card slightly smaller than the picture area. After exposing the picture, place your card carefully over the print leaving a gap around the edge. Give it a blast of white light then develop. Voilà! A black border! (Sorry, Henri!)

One theory goes something like this. In the Brownian motion of everyday life, the photographer wishes to impose order on the random ebb and flow of the surrounding world. Meaning is imposed on chaos. The "art" is in the ability to "see" beneath the surface and to extract importance. In The Decisive Moment *(1952), Henri* CARTIER-BRESSON *(b. 1908) elucidated his vision of photography, setting in stone for the next three decades the ground rules for the documentary photograph.*

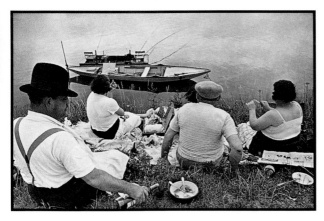

Cartier-Bresson's "Sunday on the Marne River," 1938, complete with black border.

camera. During the 1930s and 1940s he supplied picture stories for many of the leading illustrated periodicals of the time. Over this period he developed his vision of photography: that the photographer is constantly evaluating the world, looking for coincidence and the moment when all of the diverse elements within the frame will align themselves in an ideal conjunction of action and integration. The photographer taps into the "rhythm" of life and extracts the most

Cartier-Bresson trained as a painter in Paris, touched by both Cubism and Surrealism. Influenced at first by Atget, then by Kertész and Brassaï, he turned to photography in 1930 and was absorbed by the quick, quiet potential of the new Leica

1936 Bass Weejun moccasins go on sale with tassels and decorative straps.

1937 Karen Danielson Horney writes *The Neurotic Personality of Our Time*, attacking Freudian antifeminism.

1939 Igor Sikorsky makes a successful flight in his VS-300 helicopter, although there are ropes tethering it to the ground as a precaution.

"decisive" drumbeat. At the same time, there was also a sea change in subject matter: the big narratives of war and politics were being replaced by a more gentle, "cultural" vision focusing on everyday life—a picnic by the river, or the mere act of leaping a puddle, now had their own place in the cultural hierarchy.

This relocation of subject matter to something not as purposefully "documentary" allowed these images to be viewed as art. The distinctions between magazine and gallery work continued to fragment. The concentration was now on the photographer's "eye," and the photograph itself became a simple validation of this act of "seeing." The photographer *was* important!

Of course, Cartier-Bresson's "eye" was attached to Cartier-Bresson's brain, and within it his sense of himself and his relationships to the world around him. The "decisive moment" was a personal and influential exposition of his attitudes and ethics. The downside was that in a time of photographic flux, it was adopted by many photographers as a biblical text and got a bit ridiculous. "Thou shalt not crop thy pictures" and "thou shalt not get involved with thy subject matter" constrained the growth of photography, leaving many with a sense of deep underlying guilt if they dared to construct or "interfere" with the subject. Flash photography was obviously considered "cheating," since it introduced an artificiality into the natural light conditions, and if you really wanted to establish your "decisive" credentials, you printed a black border around your prints to authenticate your noncropping philosophy.

Cartier-Bresson's "The Collaborator," taken during the liberation in East Germany, 1945.

Instantaneous

Some photographs are truly decisive, inasmuch as they record events that are spontaneous, unique, and telling: examples are the shooting of Lee Harvey Oswald, or Horst Fass's picture of Richard Nixon "working" a crowd, shaking hands while looking at his watch. (The latter image is also credited to Charles Tasnadi, purporting to show Nixon on his way to lunch with King Baudouin, Brussels, 1974. Not so decisive after all.)

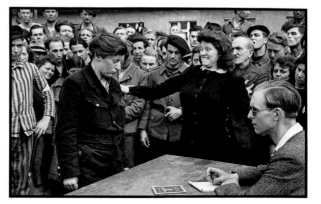

1931 A 125-ft-tall statue of Christ the Redeemer is installed on top of Corcovado (Hunchback) mountain in Rio de Janeiro.

1933 Marie Wittman of Brooklyn invents a doll that drinks from a bottle and wets its diaper. More than 25,000 are sold in the first year.

1934 Blues singer Leadbelly is released from jail after writing a song for the governor of Louisiana asking for a pardon.

1930s
Straight from the Heart
André Kertész

André Kertész's simply titled "The Fork" was shot in 1928.

Another major 20th-century photographer nearly didn't make it. As a young man covering the First World War, André KERTÉSZ (1894–1985) was shot through the heart. Recovering from this setback, he went on to establish himself as a mentor to a whole generation of rising photographers, including Henri Cartier-Bresson and Robert Capa.

He was a photographer's photographer, acclaimed by many as a master of the art. Cartier-Bresson remarked that whatever had been done subsequently, Kertész did it first.

His most significant work was produced in the 1920s and early 1930s, and ranged from photojournalism for *Vu* and the *Berliner Illustrierte Zeitung* to his surrealistic series of nudes made using a distorting fairground mirror, firstly in his native Hungary, then in Paris, where he felt

André Kertész, "Mondrian's Pipe and Glasses," taken in Paris, 1926.

Box of tricks

Often the standard lens on your camera doesn't focus close enough for that telling close-up. You have several choices: take the picture from further away and enlarge the section you want, or attach a device, such as a bellows or an extension tube, that enables your standard lens to do the job. The best option, and the most expensive, is to buy a dedicated "macro" lens, which can focus down to a 1:1 ratio where the image is the same size as the subject.

1936 The first issue of *Life* magazine appears and is followed two years later by its British equivalent, *Picture Post.*

1937 Teachers complain that the hip pocket rivets on kids' Levis are scratching the school chairs, so Levi has to cover them up.

1937 Snow White sings "Some Day My Prince Will Come" in the Walt Disney animated movie.

truly "at home." His reputation suffered in later years when he settled in New York, producing photographs for *Harper's Bazaar* and *Vogue* that lacked the passion and involvement of his early work. This showed a spontaneity and speed, as Kertész sought to identify those strange conjunctions of shape, line, texture, shadow, and form; the physical and cultural properties of objects, those unique moments of human relationships, and new perspectives of the cityscape. It is obvious from his range of subjects that Kertész

Chairs in a park near the Champs Elysées in 1930, seen through the lens of Kertész.

IN THE FRAME

*The mantle of humorous observation was to be taken up by the French photographer **Robert Doisneau** (1912–94). He produced over 325,000 negatives, many of which have become cultural icons—Picasso at the dinner table, his hands replaced by bread rolls (1952) and "Le Petit Balcon" (1953), in which an exotic dancer takes a break, sitting on the floor, her arm resting on the knee of a male spectator, while his female companion is not amused. One of Doisneau's most noted images was produced as a commission for* Life *magazine, part of a series of embracing couples intended to establish Paris in the early 1950s as the capital of romantic love. This image, "The Kiss," recently caused controversy when it was revealed that he'd hired models to pose for the picture.*

loved the act of observing and photographing. He would bring the same consideration to picturing Mondrian's glasses and pipe as he would to the arrangement of chairs in a Paris park, or the efforts of passers-by to raise a fallen horse to its feet. The much-abused term "candid" photography, meaning unobserved by the subject, was first coined to describe Kertész's work. But universal public recognition was a bit more slow in coming, and his status was only established in 1964, with a one-man show at New York's Museum of Modern Art.

1932 Picasso paints *Girl Before a Mirror*. His first marriage is breaking up and he is involved with Marie-Thérèse Walter.

1935 Federico Garcia Lorca writes *Lament for the Death of a Bullfighter*; the following year it is his death Spaniards are lamenting after he's shot by Franco's troops.

1937 General Mola, Franco's right-hand man, dies in a plane crash, but the dictator, who has support from Germany and Italy, is undeterred.

1930s~1950s

Conflict and Objectivity
War photography

By the First World War, military leaders and propagandists had recognized the power of photography and their need to control its production and publication. The Allied Command stifled the access of photographers and correspondents to the front, so that many publications had to resort to the use of "official" pictures or fictitious sketches of action. Ministries of propaganda, or "culture," sprang up in dictatorial societies to influence the flow of images to the public. As we have seen on page 72, Joseph Goebbels attempted to control representations of the German élite so that no indication of "weakness," such as Hitler wearing glasses, would find itself in the public domain. Teutonic knights were never shortsighted.

By the Spanish Civil War, enterprising photographers found their way to the battlefield in a search for the telling "action" picture. In a now familiar way, a Hungarian Jew, Andrei Friedmann, moved to Berlin, worked as a photojournalist, became disturbed by the growth of the Nazi Party, moved to Paris, and changed his name. Choosing a name from a menu of Hollywood movie stars and directors, he became *Robert CAPA* (1913–54). When he was only 25, *Picture Post* had declared him the greatest war photographer in the world. His coverage of the civil war established his reputation, with "Death of a Spanish Loyalist Soldier" (1936) becoming one of the great icons of war photography.

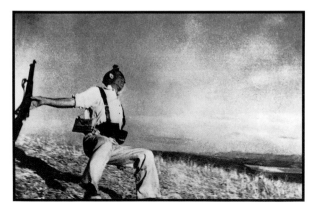

Capa's Loyalist soldier is now known to be Federico Borrell, shot in September 1936.

1942 "White Christmas" is written by Irving Berlin and recorded by Bing Crosby. Global sales are estimated to exceed $30 million.

1946 Ezra Pound is committed to a stay in a psychiatric hospital in Washington because of his support for Fascism.

1948 Fanny Blankers-Koen, a mother of two, wins four gold medals in running events at the London Olympics.

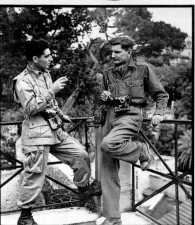

Robert Capa and George Rodger swapping photographic tips in Naples, 1943, as they followed the Allied advance.

FROM AUSCHWITZ TO KOREA

Both *Margaret BOURKE-WHITE* (1904–71) and *George RODGER* (1908–95) are notable for their coverage of the Second World War, and both found themselves photographing the liberation of the concentration camps, bringing to the public for the first time what had only been rumored, too horrible to believe. For Rodger, this was a turning point in his career. He suddenly found himself moving among the mounds of the dead, seeking good compositional viewpoints. He turned his back on war photography and concentrated on human interest stories instead.

During the Korean War, Bert Hardy, working for *Picture Post*, photographed the ill-treatment of enemy prisoners by the Allied troops. The refusal of the owner, Edward Hulton, to publish these pictures led to the resignation of the editor, and a public outcry that contributed to the slow demise of *Picture Post* as a serious publication.

> **Cheating**
> Some images have the appearance of decisiveness but have been staged, or re-staged, for the camera. The classic example of this is the raising of the Stars and Stripes by the U.S. army on the island of Suribachi, taken by Joe Rosenthal.

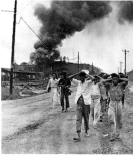

Picture Post wouldn't publish Hardy's images of North Korean POWs, 1950.

Rumors of trickery have dogged this image ever since: was it real or staged? But really, if the purpose of the picture was to raise public consciousness of this conflict, does it matter? There was little doubt about Capa's D-Day landing photographs, however—grainy, blurred images of the troops going ashore. Capa went on to cover three more major conflicts before a land mine abruptly ended his career in Vietnam in 1954.

IN THE FRAME
Russian photographer **Dmitri Baltermants** *covered the Second World War, especially the 1941 campaign in the Crimea. Much of his work was "rediscovered" in the 1980s.*

1936 The first cotton tampons on a string are marketed by Tampax Inc.

1938 Ladders are built to help salmon and trout climb up the Columbia River to their spawning grounds after the traditional routes have been disrupted by power plants.

1940 France signs an armistice with Hitler and Mussolini and the capital moves from Paris to Vichy.

Get a Life

The pages of *Life* magazine have featured many of photography's most memorable images: Sam Shere's picture of the Hindenburg crash in May 1937; Robert Capa's D-Day pictures in 1944; Charles Moore's images of police dogs attacking a black protester in Birmingham, Alabama in 1963; and Therese Frare's photograph of the death of the AIDS campaigner David Kirby, surrounded by his family.

1936~1947

New Authority
Black Star to Magnum

Until the Second World War, most photojournalists were individually commissioned, employed by publications, or were stringers for picture agencies. Freelance photographers, shooting film then selling the results to agencies or magazines, were rare. With a few notable exceptions, they were anonymous, and they were almost invariably uncredited.

In North America and to a lesser extent in France, there was a growing acceptance of the worth of reportage photography, and it was exhibited and collected. For the most part, however, many photographers felt that the credit and, more disturbingly, the control of their work went to the publishers and picture editors. It was common for the photographer to send the exposed film to the magazine and in doing so to relinquish all further involvement.

Photographers would frequently run into each other on assignments, where they could pool their disenchantment with the system. Capa and David Seymour had become close friends during the war, and in 1947 they joined

The festival of San Miguel de Allende, Mexico, taken by Elliott Erwitt.

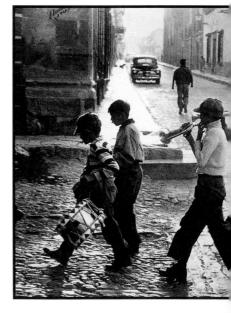

Hitler's bath

American photographer Lee Miller, former lover and protégée of Man Ray, was a war correspondent attached to the U.S. armed forces. In April 1945 she arrived at Hitler's private apartment in Munich, shortly after he had committed suicide there, and was photographed by David Sherman in his private bathtub.

1942 Peggy Guggenheim opens the Art of this Century gallery in New York and marries Max Ernst.

1946 Olivia de Havilland sets a record by thanking 27 people in her speech after winning the Best Actress award at the Oscars.

1947 Carl and Gerty Cori are awarded the Nobel Prize in medicine for discoveries connected with the metabolism of glycogen. A chemical, the Cori ester, is named after them.

forces with Cartier-Bresson and George Rodger to create Magnum, one of the first major cooperatives, based in Paris and New York. As part of Magnum, they would not only retain copyright and editorial control of their work, but also "pool" the assignments. There had been earlier collaboratives, such as Black Star, formed in Germany in 1936, but Magnum was the first to have such a heavyweight cast and a clear constitution.

Magnum wanted to unify its ethical stance with a strong marketing policy, creating and distributing its own stories. It has stayed the course, and its members read like a roll call of the great names in

Paul Newman frowns in concentration in Eve Arnold's picture of the Actors Studio, New York.

photojournalism: Eve Arnold, Werner Bischof, Bruce Davidson, Elliott Erwitt, Leonard Freed, Bruce Gilden, Philip Jones Griffiths, Josef Koudelka, Susan Meiselas, Inge Morath, Martin Parr, Marc Riboud, and Chris Steele-Perkins. Like many radical organizations, Magnum has now become the establishment, creating its own publications and exhibitions. Its ethical stance is still largely in place—the reverse of each print gives precise details for usage—but in a time of digital manipulation and a blurring of the distinctions between documentary and advertising, it will be interesting to see what will happen.

IN THE FRAME
Other picture agencies have evolved to provide competition, including **Sigma** *in France and* **Network** *in the U.K. There are also some smaller agencies, such as* **Autograph**, *whose aim is to promote the work of photographers from a range of ethnic backgrounds.*

1950 The Club Méditerrané is launched in Paris. Thousand of people apply for the first vacation in Majorca.

Majorca

1952 In the U.K., the *Sooty Show* premieres, presented by Harry Corbett.

1958 The Honda Supercub is a reliable scooter available in several different sizes, and it sells over 20 million worldwide.

1950s~1980s

The New Photojournalism

Getting into the gallery

One of the first joint "in-house" projects of the Magnum group was a series of photographs called "People are People the World Over." On one level this could be seen as stating the obvious, but in the heady days of postwar reconstruction, the idea of global unity and shared aspirations seemed attainable. Much of this work formed the core of the highly influential "Family of Man" exhibition at New York's Museum of Modern Art, curated by Edward Steichen in 1955.

Along with work from *Life* magazine and photographers Kertész and Adams, this became the world's most visited exhibition, firmly planting photography, and more specifically, photojournalism, in the public eye. This blockbuster toured many countries over the next few years, and the attendant publicity reinforced the notion of documentary as "truth," as well as Steichen's belief that the role of the photographer was to explain "man to his fellow man." One danger with this "Trust me, I'm a doctor" approach is that photography becomes "statistical"; through selective curation you merely buttress your own conceit. By the time of the exhibition, the "Family of Man" ethos seemed curiously old-fashioned to a new breed of American photographers, more concerned with social differences than with similarities.

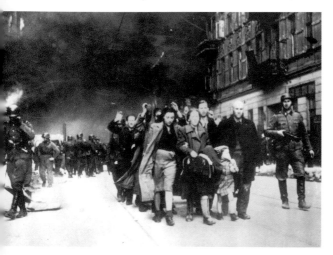

"Persecution of Warsaw Jews, Warsaw Ghetto," shown in "Family of Man."

1961 Paul Rand designs the IBM logo in a style resembling 19th-century wood-block lettering.

1976 A 4-ton meteor shower hits Jilin in China and a piece weighing 3,894lb is recovered.

1987 Only 265,000 couples marry in France this year, compared with 416,000 in 1972.

Bickering

Photography began to be divided by the Atlantic Ocean. In 1973, John Szarkowski, the Director of MoMA, observed that photographic tradition in England "died" around 1905, and that by the time Bill Brandt returned to the U.K. in the 1930s, English photography had lost its way. This did not go down too well with the Brits. Photography in the U.K. was already changing and blossoming. New educators and critics were establishing the platform for the resurgence of the last 30 years of the 20th century.

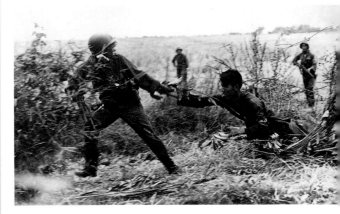

An American soldier drags a man from his hiding place. Don McCullin, South Vietnam, c. 1965.

ENTERING THE ESTABLISHMENT

MoMA continued to champion a diverse range of photographic practices, and throughout the United States photography as an exhibitable and collectable art form became widely accepted.

The U.K. was lagging behind, but the growth of the Sunday supplement in the Swinging Sixties, and the work of a new breed of high-profile, fab, and trendy photographers such as Bailey, Donovan, Haskins, and Snowdon (*see page 105*), together with crusaders such as Don McCullin (*see page 112*), at last brought photography to the breakfast table. It became part of Britain's burgeoning music, fashion, and design youth-culture explosion. No longer were photographers anonymous, raincoated figures; they had achieved celebrity, even aristocracy. Gangsters, politicians, and pop stars found their portraits hung side by side in uneasy alliance. Out of this cocktail, institutions such as the Photographers' Gallery and the Institute of Contemporary Arts, along with a host of regional galleries, emerged to promote new work. Final approbation came with the Royal Academy's "Art of Photography" exhibition in the 1990s.

1960 Martin Sharp designs the famous Jimi Hendrix poster, showing him at the center of an explosion of color, that will soon grace every student's wall.

1961 The world's most powerful atomic bomb is detonated in the USSR and the shockwave circles the world three times.

1965 There are serious race riots in the Watts district of Los Angeles after a black man is arrested for drunk driving.

1960s

Down on the Street
New visions of America

To some photographers, "The Family of Man" presented an alien vision, a portrait of homogeneity they didn't recognize. Rather than humanity growing together, they saw it falling apart. The mythic "melting pot" of American society was fragmenting, with certain groups being ghettoized on the basis of race or poverty. Their approach to photography was not based on a gently observed humanism, but a hard-edged confrontation with the "people who had fallen through the cracks in society."

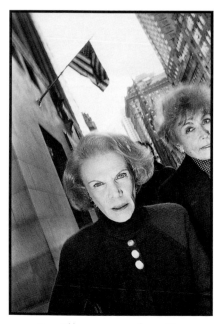

Bruce Gilden pounces on another unwitting subject in the streets of New York.

Robert FRANK (b. 1924) came to the U.S. from his native Zurich in 1947 and found a home in the New York underground Beat Generation scene. Friends with Jack Kerouac and Allen Ginsberg, he considered himself an "outsider" figure. His book *The Americans*, published in 1959, with its unorthodox subject matter and disturbing shot-from-the-hip style, shocked and outraged the Establishment, and was branded nihilistic and un-American. So, a success.

Box of tricks

American photographer Bruce Gilden continued the "street" tradition with his pictures of New York. To get that Bruce Gilden "look," set your camera up for using flash, then turn the shutter speed down to a quarter of a second. Leap out in front of your subject (exercise caution if they're out walking their pitbull), and take the picture. The flash goes off at 1/1000th of a second, "freezing" part of the picture, and the slow shutter speed picks up residual blur. Run away quickly before the subject punches you or has a coronary.

1967 Roger Patterson shoots a film in Bluff Creek, California, that purports to show Big Foot, a giant apelike creature that walks on its hind legs.

1968 There are 500,000 U.S. soldiers in Vietnam, and 300 are dying every week.

1969 The Beatles perform a free concert on the roof of the Apple Records offices in central London and traffic becomes gridlocked in the surrounding streets.

TLRs
Much of Arbus's work is produced on a twin lens reflex (TLR) camera with a waist-level viewfinder. These use medium-format roll film, giving 6cm square negatives, and have a viewing lens, for composing and focusing, set above the "taking" lens. Until improvements in the quality of 35mm film in the late 1960s, TLRs were the workhorses of photojournalists.

Images from Bruce Davidson's "East 100th Street," 1970.

Garry WINOGRAND (1928–84) followed on from Frank, endlessly photographing New York streets and functions with little regard for the formal rules of composition. Such was his passion for the act of photography that at the time of his death, Winogrand had thousands of exposed films still undeveloped. *Danny LYON* (b. 1942) also took up the mantle of "social culture," or subculture, photography, and produced books documenting Chicago's Hell's Angels and the inmates of the Texas state prisons in the early 1960s. *Bruce DAVIDSON* (b. 1933) spent two years photographing the inhabitants of East 100th Street in East Harlem in the mid-1960s, always giving prints to his subjects.

Frank's book *The Americans* became a seminal work for Friedlander and Arbus.

Lee FRIEDLANDER (b. 1934) monitored the changing social landscape of American culture. He challenged the accepted standards and recorded the incongruities of the townscape, often taking photographs from his car.

Diane ARBUS (1923–71) had a more formal approach, which owes an indirect debt to August Sander (*see page 76*): she selected the strange and the weird, posing them rigidly in their surroundings. Her disturbing vision sought out the extreme—giants and dwarves, transvestites and psychotics alike—and the disabled. She saw them as "aristocrats" who had faced their life traumas and passed the test. In 1971 Arbus took her own life.

1862 Lewis Carroll writes the first *Alice* stories for Alice Liddell, the daughter of the Dean of Christ Church College, Oxford.

1865 A retired army surgeon, Dr. James Barry, dies in London. The postmortem reveals that he was a woman and had borne a child.

1942 When park ranger Roy C. Sullivan is struck by lightning for the first time, he loses his big toe nail. He will be hit 6 more times before he kills himself in 1983 after being rejected in love.

1860s~1980s

Through the Looking Glass
The child and the adult gaze

Alice Liddell photographed by Lewis Carroll, 1858.

We tend to think that the Victorians "reinvented" childhood. With new education and child labor laws on both sides of the Atlantic, early childhood, especially for the middle classes, moved from ignorance and drudgery to soft-focused idylls of picnics and play. This new-found "innocence" of the young found its expression in painting and photography (innocence being associated with nudity). In "artistic" circles, prancing around neoclassically in the morning dew with one's clothes off wouldn't have raised an eyebrow.

These days we are bound to have mixed feelings when confronted with the surviving photographic work of the *Reverend Charles Dodgson* (1832–98), better known as Lewis Carroll, author of *Alice in Wonderland*. Borrowing from a style established by Oscar Rejlander (*see page 27*), Dodgson produced many photographic studies of young girls, often nude or partly dressed, over a period of 24 years. His motives remain unknowable; he was operating in a time of confusion. The laws of consent were under review: in the U.K., until 1861 intercourse with a child of 12 was merely a misdemeanor. The age of consent was raised to 13 in 1875 and to 16 in 1885. Prior to this it wasn't unusual for a girl of 13 to be married (ask Edgar Allan Poe). Dodgson ensured that he got permission from his subject's parents and

1966 American abstract artist Barnett Newman paints *Who's Afraid of Red, Yellow, Blue.*

1978 The London edition of *The Times* on August 22 has 97 misprints in 5½ column inches on page 19, in a passage about "Pop" (Pope) Paul VI.

1984 Arnold Schwarzenegger plays an android assassin in *The Terminator.*

seems to have met with little objection or moral outcry. His reasons for asking his executors to return all of these portraits to the sitters or destroy the negatives on his death are not recorded.

As cultural climates change, the content of photographic work slips in and out of the realms of acceptability. A century later, there is no doubt that Dodgson would have experienced an extended period of license plate-making for this work.

A fundamental difference in perception exists between the photograph and the painting. However contentious, the subject matter of painting can be created from the imagination, but with photography there is always the belief that the "real" thing actually had to be there at a certain point in time in front of the camera (a dubious distinction). The nude in "art," with its

historical antecedents, is therefore more acceptable than its photographic equivalent, even by association—as we see with Hans Bellmer's dolls, photographs of which were considered shocking in themselves.

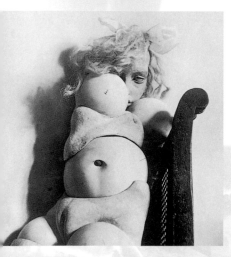

Bellmer's "La Poupée," c. 1934, with her enlarged genitalia and blank expression.

IN THE FRAME

Hans Bellmer *was a member of the Surrealist movement. In the 1930s, he began to work with a doll he'd made, endlessly repositioning its articulated limbs and photographing it in a variety of suggestive poses. The savage dismemberments he inflicted on "La Poupée" suggest a deeply troubled soul, but his images have become influential, especially in the work of Cindy Sherman and Francesca Woodman (see page 126).*

Kids' stuff

When a man photographs children, we are left with a tinge of doubt about his motivation. In a climate of moral panic, this can lead to a policeman waiting for you when you come to pick up your prints of the kids in the bath or playing on the beach. When a major retrospective of Robert Mapplethorpe's work (*see page 118*) was taken to London for a prestigious show in the mid-1990s, among all the other images of Mapplethorpe's one could take issue with, it was a picture of a naked girl that was impounded by customs. Much of American photographer Larry Clark's work with teenagers has also been controversial and Sally Mann's *Immediate Family* (1992), documenting her children growing up, often playing naked, has been variously described as honest and open or simply naive.

1941-2 Salvador Dali designs window displays for Bonwit Teller in New York; they only exhibit a toned-down version of his lurid ideas and he retaliates by smashing the glass with a sledgehammer.

1944 Judy Garland appears in Vincente Minnelli's *Meet Me in St. Louis* and they marry the following year.

1967 Jorge Luis Borges writes *The Book of Imaginary Beings*.

1930s~1990s

Documentary Fictions
Mexico and South America

In South America, three photographers were documenting people's lives: in Peru, Martín CHAMBI (1891–1973) was quietly compiling a body of work centered around his home city of Cuzco; in Mexico, Manuel Alvarez BRAVO (b. 1902) was influenced by the Surrealists in his work, while Pedro MAYER (b. 1935) has political references in most of his images. Their pictures range from studio portraits to documentary shots, and jointly they put South American photography on the international map.

Murals
Diego Rivera brought a revolutionary, socialist spirit to Mexican art using the mural painting as a political tool. In 1921, he was commissioned to create a series of murals at the Escuela Nacional Prepatoria in Mexico City, and his overtly political choice of subject matter so outraged some right-wing students that he was forced to work with a loaded pistol in his belt. His murals have titles like *Entering the Mine, Revolution will Bear Fruit*, and *Freeing the Peon.* You get the drift?

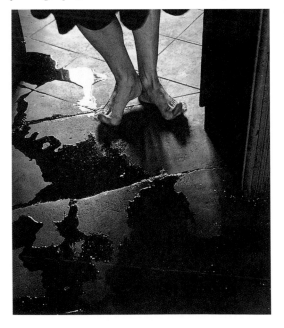

Martín Chambi's passion for his subjects brought a grandeur and dignity to his pictures, which range from portraits of musicians and families to street scenes and carnivals, all of them providing a loving document of an era. For Manuel Alvarez Bravo, it was a meeting with Tina Modotti in 1927 that inspired him to treat the medium seriously. Her encouragement helped Bravo to become a leading figure in the growing Mexican art movement of the 1930s. Meeting Diego Rivera and

"The Threshold" by Manuel Alvarez Bravo—a simple subject in an uncomplicated setting.

1980 Brazil's Serra Pelada gold mine is discovered by miners when a tree falls over during a storm, uncovering some interesting-looking rocks.

1982 Argentine scrap merchant dealers land on the island of South Georgia and the Falklands War begins.

1993 Valentine's Day is celebrated in Turkey for the first time, with hotels offering half-price deals for couples.

Frida Kahlo lured him toward the Surrealist movement, whose ideas suffused much of his work of the period. By the mid-1930s, Bravo was exhibiting alongside Cartier-Bresson and Walker Evans.

Pedro Mayer began his love affair with photography at the age of 12, and by the mid-1970s had exhibited widely throughout Mexico and North America. His early work centers on cultural references in a traditional documentary form, but with an awareness of the fact that the reading of an image differs according to the mores and customs of a society. So for Mayer, an image of a naked Mexican girl is political, signifying the cultural "submission of the woman in our latitudes" without the prurient overtones other perspectives might graft onto the image. More recently, Mayer has adopted digital manipulation, marrying documentary forms with religious iconography.

Box of tricks

Visit the ZoneZero web site at http://www.zonezero.com. It's one of the few sites that provides calibration guides so you can adjust your monitor to display graphics accurately. It has portfolios and photographic essays as well as articles by and about photographers.

Pedro Mayer runs the highly influential "ZoneZero" web site.

Gold mines

Sebastião Salgado documented the vast Serra Pelada gold mines in Brazil in 1988 as part of his global series on "workers." At the time he worked for Magnum; he is now a Network photographer.

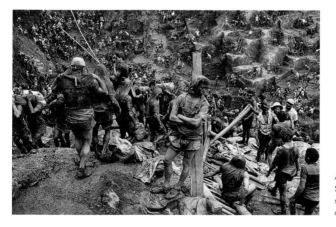

A Salgado photograph of Serra Pelada in 1988, showing the appalling conditions for workers.

1951 South Africa's Department of the Interior issues cards to all residents classifying them as white, black, or colored.

1957 An edition of the Bible is published with illustrations by Marc Chagall.

1963 David Hockney produces *Play within a Play*, a painting of a tapestry with a vertical strip of plexiglass on top.

1950s~1990s

Through a Glass Darkly

Drum magazine

There are some places whose names resonate in the mind because they stand for an event—like Hiroshima, Pearl Harbor, Chernobyl, Three Mile Island, or Waco—that goes beyond location. They represent something deeper to us, a reminder of the depths of callousness or stupidity that human beings are capable of.

In 1960, the small South African township of Sharpeville reluctantly found itself in this category. Dozens of civil rights protesters were shot by the police, 69 were killed, and Sharpeville became the focus of global attention; as a consequence, the apartheid regime became the focus of

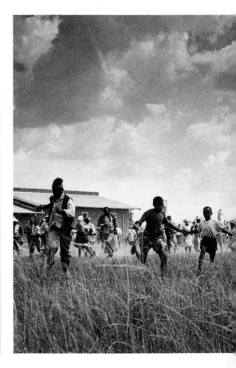

Children being shot: one of Ian Berry's opinion-forming pictures of the Sharpeville massacre, 1960.

IN THE FRAME

Bob Gosani *photographed the "shebeens," the drinking houses that became a central part of township life in South Africa. The shebeens were not only centers of entertainment but also places for activists to meet, because many other venues were regulated under the apartheid laws. Under the guidance of Jurgen Schadeberg, a German immigrant who ran the photographic department of* **Drum**, *Gosani documented and lived the wild life of the shebeens. His motto was, "Live fast, die young, and have a good-looking corpse."*

1977 South Africans see television for the first time. It had been banned previously as the government thought it would be morally corrupting.

1986 Poisonous gas leaks out of Lake Nyos in Cameroon and kills up to 1,200 people.

1994 The phrase "road rage" is first used to denote the anger induced in drivers by traffic conditions and the behavior of other drivers.

global criticism. Lancashire lad *Ian BERRY* (b. 1934) moved to South Africa in 1952 and became a regular contributor to *Drum* magazine. After Sharpeville, his images of the dead and dying scattered on the township's streets made every front page and played an instrumental part in galvanizing world opinion.

Drum was the *Picture Post* of Africa, but with a slightly more political edge. It was originally established in Cape Town in 1951 as *African Drum*, a magazine dealing with tribal issues, but its condescending approach doomed it to failure. It was bought out a few years later by Jim Bailey, who brought in an experienced and innovative editor, Anthony Simpson. He relocated *Drum* to Johannesburg, where its balance of human-interest stories, high-quality photography, popular culture, and subtle politics soon established it as a winner. Within a few years, *Drum* had regional offices and editions throughout southern Africa. The range of photographers and correspondents working for *Drum* covered all colors, and included the renowned Bob Gosani. *David GOLDBLATT* (b. 1930) photographed the working conditions of the migrant miners in 1973 and published *Lifetimes under Apartheid* in 1986.

The heyday of *Drum* was in the 1950s and 1960s, when it managed to provide a platform for antiapartheid views without running afoul of the authorities and ending up being banned like many of its contemporaries, but the readership had dropped off by the 1990s.

Sharpeville

Ian Berry and the assistant editor of *Drum*, Humphrey Tyler, were the only journalists at Sharpeville on the day when over 200 peaceful protesters were shot down. As the crowds ran past, many of them were laughing, as they assumed that the police must be firing blanks.

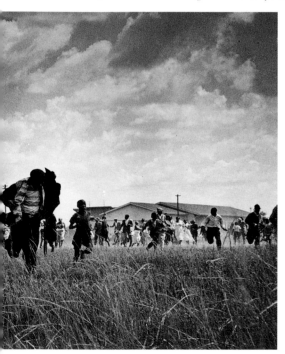

1950 The most violent earthquake ever recorded hits Assam in India but no one can measure it because it sends the needles skidding off the seismographs.

1966 There is a steep drop in the birth rate in Japan this year because it is believed that girls born in the "year of the horse" will not find a husband.

1973 Linda Blair vomits all over priests and rotates her head 180 degrees in The Exorcist.

1950s~1990s

Other Perspectives
Raghubir Singh and Abbas

The history of photography seems to have been dominated by a white middle-class male gaze surveying the world around it. As we have seen, major events and personalities were centered around France, Germany, the U.K., and North America, as if little of significance or concern was generated in the southern hemisphere or in Asia. Such places were regarded as exotic, to be explored and surveyed, but somehow inferior.

IN THE FRAME

Photography occupies an uneasy position in Islam, whose laws limit the depiction of animals or the human body in art. It maintains a delicate peace by identifying the photographic practice firmly as documentary. Many cultures see photography as a subversive medium, and laws of censorship and propriety exclude much of what is acceptable in the West. The more dictatorial the state, the greater the restrictions on what can be photographed. The majority of the Chinese people have no access to the hundreds of images of the events in Tiananmen Square and no knowledge of the infamous crushing of the democracy movement.

"Wrestlers and Sculpture of Bhima Ram Ghat" by Raghubir Singh. His pictures are full of the color and incident of his native India.

This deeply entrenched colonial view to some extent still permeates photographic practice. It is considered acceptable to show graphic detail of suffering in developing countries, but not to display the anguish of Western citizens. Yet, elsewhere, life and photography go on, addressing pretty much the same concerns, practices, and issues.

The Indian photographer *Raghubir Singh* (1942–99) enjoys a formidable reputation on the Indian subcontinent and in the U.S. His color documentary work on Indian life is the equal to anything produced in the West. Since the 1940s he has regularly exhibited new bodies of

1986 A Beirut magazine reveals that the U.S. has been selling arms to Iran, hoping that it might help to get their hostages released. Colonel Oliver North and Vice Admiral Poindexter resign.

1990 Saddam Hussein forces six-year-old British boy Stuart Lockwood to appear on television with him to demonstrate his "human shield."

1996 A new planet is discovered orbiting the sun and is given the exciting name of 1996TL66.

work, often dealing with specific regions: these collections include "Ganges" (1974), "Calcutta" (1975), "Rajasthan" (1981)—Singh's home state—and "Bombay" (1994).

A 1979 Abbas photo of a woman, believed to be a supporter of the Shah, being lynched by a Revolutionary mob in Tehran.

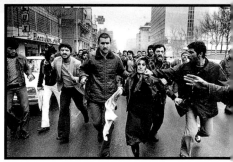

Sometimes a language, nationality, or religious persuasion, or even specific "local" knowledge, can enable photographers to gain access to events excluded to others.

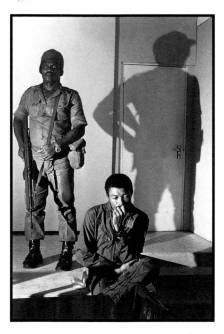

Group Captain J.J. Rawlings after his second coup in Accra, 1982.

Abbas's photojournalism has a deserved reputation for being hard-hitting.

We see this with the work of Judah Passow, who covered the events in Palestine and Lebanon in the 1980s, and Abbas, the Magnum photographer.

ABBAS (b. 1944) became a freelance photographer in the 1970s, covering events in Biafra, Northern Ireland, and Vietnam. In 1978 he returned to his native Iran to document Islam, the overthrow of the Shah, and the progress of the Revolution, in *The Confiscated Revolution* (1980). Since the mid-1980s Abbas has worked on a personal project exploring the communities and rituals of the Christian and Islamic worlds.

Box of tricks

When photographing dynamic events, there is often not enough time to calculate the exposure and refocus for each image. The way around this is to take a light reading in advance, usually from a shadow area, having chosen a shutter speed that will render action sharply. Prefocus the lens on 8 to 10ft. Now all you have to do is *look*, wait for that significant event (this can be the boring part), bring the camera up to your eye, and take the picture. Being in the right place at the right time is also useful.

1936 A Tokyo geisha is arrested for killing her unfaithful lover, cutting off his penis, and carrying it around in her *obi* (sash) for three days.

1942 A pointer named Judy, the ship's mascot on HMS *Grasshopper*, is captured by the Japanese and interned at a POW camp.

1954 Screwworm flies are successfully eliminated from the island of Curaçao after scientists introduce a swarm of sterilized males.

1930s~1980s

From Pastoral to Political
Hills and clouds

As we have seen, landscape photography is problematic. Standing before a mountain or in a desert gives the observer a new kind of perspective. The longevity of geological time sharpens the sense of mortality. It is not just the physicality of the experience that the photographer has to capture, but also a huge range of emotional responses that are an intrinsic part of being there.

> **Box of tricks**
>
> Many landscape photographers, in order to achieve maximum detail in their images, use "large format" or field cameras. These take sheets of film that produce a 4" x 5" or 8" x 10" negative. Working to a negative this size means that large-scale enlargements that render the fine detail in the original subject can be made with little degradation of the image.

"Moonrise, Hernandez, New Mexico" by Ansel Adams, 1941.

For *Ansel ADAMS* (1902–84), this meant seeking the "right" location and waiting for the appropriate conjunction of clouds and light. When trying to present the "sublime" landscape, one's sense of the inferiority of the simulacrum becomes ever more keen. All these woolly "equivalents" don't add up to a hill of beans.

In 1950s Britain, one of photography's great unsung heroes, *Raymond MOORE* (b. 1920), started rethinking the landscape. He reinvented the language, bringing the everyday and the mundane into focus. He looked at the ground, rather than invoking some starry, zenlike mysticism. He was concerned with making photographs rather than creating aide-mémoires.

Another British photographer who concerns herself with the landscape, the intrusion of industry and housing, and the effects of pollution and mismanagement, is

Fay Godwin, "Russell's Enclosure, The Forest of Dean."

Climb every mountain

Mountains present a particular challenge to the photographer, especially those that feel the need to climb up them. The classic picture of the goggled and triumphant creatures who have scaled these things shows them thumbs up and exuberant. Unfortunately, most of them are so wrapped up against the elements they could be anyone. You need to go back to the beginning of the last century when fellows in knickerbockers and stout shoes would stroll up the Matterhorn before lunch. The biggest mountain photography mystery is where George Mallory's camera ended up. This vest-pocket Kodak contains the evidence to prove once and for all whether Mallory, in his tweed suit, with his Thermos flask of tea and packet of sandwiches, scaled Everest decades before Sir Edmund Hillary and Tenzing Norgay made the jaunt in 1953.

Fay Godwin (b. 1931), a former president of the Ramblers' Association. Her work acknowledges the majesty of the landscape, while maintaining an unerring eye for the telling detail of intrusion. Other contemporary landscape photographers and educators of note are Thomas Joshua Cooper, John Davis, and John Blakemore.

In mid-1970s America, a group of like-minded photographers banded together under the title of the "New Topographics" to explore the landscape with a "dispassionate" eye, documenting the incursions of society into the great outdoors. Their work was deliberately "cool," rejecting such notions as form or presence, attempting to distance themselves from personal opinion, and harking back to O'Sullivan and Watkins in their approach. Among this group were Robert Adams, Lewis Baltz, Bernd and Hilla Becher, Joe Deal, Nicholas Nixon, and Stephen Shore. This sense of detachment was so extreme that Baltz, for one, hoped that his images achieved total sterility—without emotional content, non-judgmental and devoid of any kind of moral commentary.

1923 Adolf Hitler is arrested in his pyjamas the day after attempting to overthrow the German government.

1936 Raoul Dufy designs a tapestry called *Amphyrite* for Marie Cuttoli; it is a homage to the sea that plays with perspective.

1953 The first issue of *Playboy* has Marilyn Monroe as the centerfold.

1920s~1980s

Form Follows Function
Vorsprung durch technik, or whatever

New technological developments create a void that artists and photographers are only too happy to leap into. Moholy-Nagy (see page 66) appropriated X rays and photomicrographs, which were later to be reevaluated by Gilbert and George (see page 125). The electron microscope and the polarizing filter brought a new universe into the public domain. Harold EDGERTON (1903–90) developed the ideas of Muybridge (see page 36), creating very high-speed flashguns that froze the movement of a water droplet, a bullet, or a bat's wing in flight.

Developments in lens and film technology paved the way for smaller cameras that could take good pictures in available light, liberating photojournalism and expanding the market for domestic photography. To measure the light when calculating their exposure time, early photographers would monitor the relative dilation in the eyes of pet cats. The light meter, first hand-held then later built into the camera, was not only more accurate, but also a great blessing to the cats.

In 1963, the Polaroid Corporation produced their first instant film camera, with peel-apart prints, and the Polaroid "Swinger" went on to become a major fashion accessory in the mid-1960s. In

Harold Edgerton, ".30 Bullet Piercing an Apple," c. 1964. All in the name of science.

1966 German businessman Günther Sachs woos Brigitte Bardot by flying over her house in a helicopter and dropping thousands of rose petals.

1973 The book *Real Men Don't Eat Quiche* explains how to become truly masculine.

1980 A surrogate mother accepts payment for carrying Baby M, then refuses to give her to the biological father and his wife. A complex court case ensues.

Disappearing acts

In the official picture of Chairman Mao's funeral, China's top politicians line the stage, heads bowed toward the camera, while behind them stand the massed lines of mourners. There are conspicuous gaps in the row of top brass where the Gang of Four have been "airbrushed" out of history, leaving ghostly silhouettes with faintly discernible outlines. A more competent retouching can be seen in the classic image of Lenin addressing the Revolutionaries in 1917: in the original, Trotsky listens attentively, but his image disappeared from future prints after he fell from favor.

"Earthrise," the view of the rising Earth from Apollo 8, 240,000 miles away.

1972 they perfected the single-sheet system, where the print is ejected from the camera and develops before your eyes. The first camera to use this, the SX-70, became a design classic and spawned a whole new subgenre of photography (two, if you count home pornography).

By the 1970s, color print film and the low cost of processing, together with cheap, simple-to-use cameras, heralded the slow marginalization of black and white, and the growing democratization of photography. At this time as well, the space program was providing a whole new set of images and perspectives: by the early 1970s "Earthrise" was on every student's bedroom wall, alongside R. Crumb's "Keep on Truckin'…" image.

But it is the microchip and the computer that have had the most radical effect on photography in the last century. Advances in software in the 1980s have meant that the manipulation of images is now undetectable. The forensic fall-back of photography, the original negative, is missing. You no longer have to have the original subject there in front of the camera. Unlike photomontage, which was quite overt in its production, and even unlike the judicious cropping out of history of various disgraced politicians, image manipulation is increasingly altering the perception of the nature of photography, especially documentary photography.

Box of tricks

Early political tinkerings with history were often crude and amateurish, but with modern software applications, photographs can be doctored so seamlessly that illusions can be hard to spot. Altering the meaning and subsequent reading of an image is now commonplace. Whether it is replacing the beer glass of a Socialist politician with a champagne bottle or manipulating a photograph of Princess Diana and Dodi al Fayed to make them seem on the verge of an embrace, the tabloid press and the propagandists have a new, invaluable tool at their disposal.

1951 Sheepfarmers in Australia introduce the myxomatosis virus in an attempt to kill off some of the rabbits that are eating enough grass to feed 40 million sheep.

1958 Moroccan women gain the right to choose their own husbands and polygamy is restricted.

1965 Bob Dylan releases the seminal album *Bringing it All Back Home*, mixing white culture with R&B.

1950s~1970s

A Hard Rain's Gonna Fall

Shooting in Nam

Eddie Adams's "Vietnam Execution" won a Pulitzer Prize in 1969.

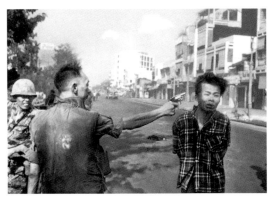

When the Americans took over the running of the Vietnam War from the French, they were on a roll. In the warm, economic-boomy afterglow of the Second World War, their "triumph" in Korea (technically a draw), and a growing ascendancy in the Cold War, this little local difficulty in Southeast Asia looked as though it was going to be a cinch. Most Americans felt they could trust the government under Lyndon B. Johnson to get on with it; although it was only a few hours away in a B52, Vietnam might as well have been on Mars. No one thought that the Vietnamese would be able to put up much of a fight. Well, they could—and they did.

Before long the mad economics of flattening a forest with high-level "saturation" bombing to knock out some poor bugger with an AK47, who's quite sensibly sitting deep in a tunnel, began to tell. And every evening on the TV and in their morning newspapers, American families saw the relentless carnage

The dilemma
Nick Ut's picture is nearly always shown with the left-hand edge cropped, otherwise we'd see that the road is lined with photographers watching the fleeing family. This would raise issues of bystandership—the eternal question of whether the photographer should help the wounded or record the event.

unfold. Vietnam was the first, and probably the last, true media war, with unfettered access for photographers, many of whom became caught up in the excitement of that "smell of napalm in the morning" thing. The sheer weight of images finding their way back meant that a qualitative editing

1968 News of the Mai Lai massacre, where hundreds of Vietnamese men, women, and children are shot by American soldiers, is suppressed for 20 months.

1976 There is scandal after Margaret Trudeau, wife of the Canadian premier, spends a night in a hotel room with the Rolling Stones.

1979 The movie *Apocalypse Now* is finally released. Shooting ran 147 days over length and $19 million over budget after a typhoon nearly destroyed the sets, civil war broke out in the Philippines, and Martin Sheen had a heart attack.

Nick Ut's "Children Fleeing an American Napalm Strike," 1972.

process was impossible, so the public was deluged by quantity.

Occasionally, a single image rose up above this cloud base and caught the public's attention. *Huynh Cong "Nick" Ut's* (b. 1951) picture showing a badly burned girl fleeing her village nearly wasn't published because the picture editor was worried by the depiction of nudity. *Eddie ADAMS'* (b. 1933) still showing a South Vietnamese officer summarily shooting a prisoner in the street countered the one-sided propaganda regarding treatment of prisoners. Before he was killed at Langvie, *Larry BURROWS* (1926–71) documented the bravery of a helicopter patrol attempting to rescue a wounded colleague. In 1969, he published a highly influential photo-essay in *Life* magazine documenting his doubts about the war.

Marc RIBOUD (b. 1923), perhaps best-known for his image of an anti-Vietnam protester offering a flower toward the bayonets of the National Guardsmen, toured North Vietnam to "humanize" the enemy. Others, such as Sean Flynn and

Tim Page, were among the "wild child" contingent, risking and, in Flynn's case, losing, life and limb in the pursuit of action. Philip Jones-Griffiths' book *Vietnam, Inc.* is probably the most savage and reflective document on the war.

IN THE FRAME

Life *photographer* **Joe McNally** *discovered PhanThi Kim Phuc, the girl in Nick Ut's image, living in Toronto in 1995 and made a series of pictures of her with her small child. Eddie Adams rediscovered General Nguyen Ngoc Loan, the South Vietnamese officer who had troubles with the Geneva Convention's ruling on POWs. He was running a pizza parlor in the States.*

1938 The song "The Flat-foot Floogie" comes out, after the lyricists have been forced to change the word "floozie" to "floogie."

1945 Eva Duarte mobilizes the workers of Buenos Aires to get Juan Perón released from jail. Five days later, he marries her.

1947 The first photo-romance is published in Italian magazine *Il Mio Sogno* (My Dream).

1920s~1960s

Society Girls and Soft Focus Filters
Fashion photography

When we look at the lives and work of the great masters of photography, we get the impression that they were either independently wealthy or lived on thin air. How they earned a crust is downplayed, as if this would lower their stature or demean the work. When we think of Man Ray, it is unlikely that his advertisements for spearmint chewing gum first spring to mind.

In fact many famous photographers, including Kertész, Cartier-Bresson, William Klein, Diane Arbus, and Robert Frank, worked extensively for magazines. In the early years of the 20th century, Condé Nast established *Vogue, Harper's Bazaar,* and *Vanity Fair,* which by the 1920s had gained a reputation for "up-market" fashion and portrait photography.

In 1914, *Vogue* hired Baron De Meyer as its first director of photography. He was chosen for his society contacts and "high-art" reputation, and brought with him his own brand of fluffy Pre-Raphaelitism.

An Irving Penn photograph on the cover of *Vogue,* October 1944.

IN THE FRAME

In 1939, **Irving Penn** *was working as an art director in New York. He became frustrated with this career and dabbled with painting before finding his métier as an assistant to Alexander Liberman, the art director of* Vogue. *Gradually, he moved toward photography and achieved his big breakthrough in 1943 with his first* Vogue *cover. He is now seen as one of the 20th century's leading lights and is a member of the ten-man faculty of the modestly named "Famous Photographers School."*

Fashion photography at this time was essentially the aristocracy at leisure, with formalized sets and poses. The transition of *Vogue* from society journal to fashion magazine took place under the

1951 Nancy Mitford says "An aristocracy in a republic is like a chicken whose head has been cut off: it may run about in a lively way but in fact it is dead."

1957 African bees imported into Brazil escape and head north. They will kill hundreds of people over the next 33 years.

1968 Ettore Sottsass designs the "Astroide" lamp, which is pink on one side, blue on the other, and made of plastic and metal.

Famous for being famous

Richard Avedon takes much of the reponsibility for elevating the status of the fashion photographer in the 1950s and 1960s. His dramatic compositional techniques combined with new relationships between photographer and the—now professional and highly paid—models. Photographers themselves became fashion and style gurus, and their lives and affairs became headline news. Thanks for that, Richard.

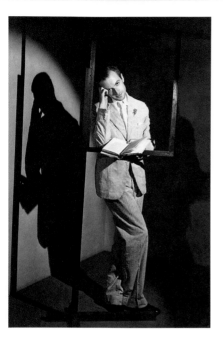

Cecil Beaton looking impossibly dainty in a photo by Gordon Anthony, c. 1940.

and *Richard AVEDON* (b. 1923) brought the "New Look" to the pages of *Vogue* and *Bazaar* with a starker, dramatic style. From the 1930s onward, Cecil Beaton, Norman Parkinson, and the soon-to-be Lord Snowdon were treading a fine line between class consciousness, with the occasional nod toward the aristocracy, and a very British mix of documentary with a hint of the surreal.

By the 1960s, photographers such as David Bailey and Terence Donovan, both students of the influential John French, brought the new youth culture, and kids' rejection of their parents' values, to the depiction of fashion.

guidance of Edward Steichen (*see page 56*), who brought a fresh look to its pages, hiring Munkacsi, Hoyningen-Huene, and Horst. *Martin MUNKACSI* (1896–1963) shocked the fashion world by photographing swimwear models actually running down a beach. This was radical stuff. Influenced by the Constructivists and the avant-garde, the swimwear pictures of *George HOYNINGEN-HUENE* (1900–68) and *Horst P. HORST's* (b. 1906) "Mainbocher Corset" image have become icons of Modernism. By the late 1940s *Irving PENN* (b. 1917)

David Bailey, 1966. He says "I never cared for fashion much … it was the girls I liked."

1950 Lovers Ingrid Bergman and Roberto Rossellini are hassled by photographers, even after they marry.

1963 Christine Keeler has simultaneous affairs with the U.K. Minister for War, John Profumo, and an official at the Soviet Embassy, in what government figures consider to be a security risk.

1972 American swimmer Mark Spitz wins a record seven gold medals at the Munich Olympics.

1950s~1997

"Over Here, Love!"

Fame and the media

When we see photographs in the tabloid press of Fergie cavorting topless on a beach in a toe-sucking situation with her financial advisor, we're filled with mixed emotions. Putting aside our natural first reaction—to burst out laughing— there are the considerations of privacy and the dual standards of the press to take on

Sarah Ferguson's lover, John Bryan, appears to be enjoying his new-found notoriety, 1992.

board. We are all complicit in this duality: the conceits of celebrities and strange nocturnal habits of politicians and the judiciary bring us undeniable pleasure. Where do we draw a line in the sand? To what extent are those that court publicity able to pick and choose the information and images that reach the public domain?

Jackie Kennedy captured by a photographer with a long lens.

Starting in the 1920s, the growth of the Film Star and the parallel development of picture magazines fed the market for celebrity pictures and prurient stories. Gossip became lucrative. By the 1950s the paparazzo photographer, working as a freelance or with secretive links to specific publications, dogged the footsteps of society figures, looking for indiscretions. Some of these men became celebrities in their own right, often maintaining an uneasy truce with their targets. Ron Galella, a leading paparazzo, pestered Jackie Kennedy to the extent that she took out an injunction barring him from approaching closer than 50 feet.

1974 British aristocrat Lord Lucan disappears after his wife is attacked and their children's nanny murdered.

1984 Koo Stark gets the tabloid doorstep treatment when it is rumored that she's having an affair with Prince Andrew.

1995 Hugh Grant is caught with prostitute Divine Brown in a car on Sunset Boulevard.

By the 1980s the number-one target for the paparazzi was the Princess of Wales, especially after the breakup of her marriage. Rumors of affairs and eating disorders fueled the race for the most telling pictures. There were millions to be won. So it was almost inevitable that when she died in that car crash the swarms of paparazzi chasing the Mercedes would take the brunt of the public anger. The tabloid press distanced themselves from the paparazzi with a rapidity only matched by their eagerness to print such images in the weeks and days before the accident.

It is too early to tell if these events have marked a watershed in the career of the paparazzi. Public memories are short, demand is great, and sooner or later a new juicy set of pictures will be summarily snapped up.

IN THE FRAME

Frustrated attempts to photograph royalty are nothing new. In the 1860s **Thomas Skaife**, *the inventor of the "Pistolgraph" camera, pointed this device at Queen Victoria. He was immediately wrestled to the ground by that period's equivalent of today's Secret Service agents, and Skaife lost his potentially historic image because he had to open his camera to demonstrate his innocence.*

Buzz off

The term "paparazzi" derives from "Signor Paparazzo," a character in Federico Fellini's 1960 movie *La Dolce Vita.* In colloquial Italian, *paparazzo* means a buzzing insect.

Diana was plagued by photographers every time she left her home.

1956 Billie Holliday's autobiography, *Lady Sings the Blues*, is published. It tells of her battles with drink and drugs and her tragic personal life.

1961 Yuri Gagarin is the first man in space. He ejects from his spacecraft 108 minutes after the launch and lands safely.

1964 Muhammad Ali describes his boxing style—"Float like a butterfly, sting like a bee"—and takes his first world heavyweight title.

1950s~1980s

Dreaming in Color
It's not all black and white

Black-and-white photography had a good 80 years' headstart before an acceptable color process was developed. Even then, it was nearly another half century before documentary photographers began to take it seriously. Black and white had authority; it distanced the audience from the everyday world of color; it lifted the photograph from its surroundings and, well, made it art.

Box of tricks

The race for acceptable color film was between the Eastman Kodak company and Agfa in Germany. In 1935, Kodachrome, the first 35mm transparency film, was marketed. Slides were returned in 2-inch square cardboard mounts, and these served to regenerate the moribund magic lantern into the modern slide projector. Agfa responded a year later with transparency film that could be home processed. It wasn't until the 1940s that Kodacolor was produced, the forerunner of modern color negative films.

Some of the New Topographic photographers, inspired by the growing pop culture and disenchanted by the pretensions of traditional black and white, embraced the color medium. *William Eggleston* (b. 1939) found the trivia and bric-a-brac of the U.S. more telling and informative than its grand vistas. Color and detail were important, because they had been selected by the otherwise anonymous individuals whose dwellings and towns he photographed. In "Red Room, Greenwood, Mississippi," the deep red of the walls and ceiling are broken by an array of wires spreading from the central light fixture, and on the edge of the frame there is a glimpse of posters demonstrating sexual positions. His composition is unconventional,

William Eggleston, "Red Room, Greenwood, Mississippi."

1972 Lana the chimp learns to use a PC keyboard. After 3 years, she has a vocabulary of 120 words and can ask for a cup of coffee in 23 different ways.

1978 King Hussein of Jordan marries American Lisa Halaby and she becomes Queen Nour-al-Hussein.

1982 Seiko launches the TV wristwatch, with a black and white screen 30.5mm wide.

hinting rather than expounding. The viewer is left to consider the image as a photograph, rather than a document, and to construct a narrative from the clues provided. Eggleston's work was deliberately unexotic, indecisive, the subjects banal, and the images are more disturbing because of it. For instance, his photographs of Graceland, Elvis Presley's homage to kitsch, are at once amusing and quietly sinister.

Bizarre
Joel Sternfeld's book *American Prospects* (1987) brings wit and whimsy to the color documentarists. Where else would you encounter a collapsed elephant on an American street?

By the 1980s, color was becoming more favored, the artificiality of black and white no longer acceptable. A new wave of British photographers, led by Martin Parr, Paul Graham, David Moore, Paul Reas, and Anna Fox, turned their backs on monochrome and its conventions.

Joel Sternfeld, "Exhausted Renegade Elephant, Woodland WA, June 1979."

Eggleston never felt comfortable with black and white, and as color film became sophisticated enough for gallery-quality reproduction, other photographers joined him in turning to it. Joel Meyerowitz and Stephen Shore introduced a cold, topographic edge to the cityscape and the small town at night, while Alex Webb brought color into documentary.

IN THE FRAME
In the 1960s, **Joel Meyerowitz** *(b. 1938) worked as an art director at a New York ad agency, but when he saw Robert Frank's* The Americans *he was so moved that he turned to photography. Like the photographs of Garry Winogrand, his early work focuses on urban street incidents. In the 1970s he began to work in color, producing bodies of work portraying American cities—St. Louis, Atlanta, and New York.*

1971 The FDA advises Americans to stop eating swordfish because of its mercury content.

1975 Model Norman Scott's Great Dane is shot and he claims it is part of a plot to kill him by Jeremy Thorpe, leader of the British Liberal Party.

1977 Marius Casadesus admits authorship of the *Adelaide Concerto*, which had fooled the music world after it was attributed to the 10-year-old Mozart.

1970s~1980s
More of the Same
Typologies

Bernd and Hilla Becher, "Typology of Half-timbered Houses," 1959–74.

For some photographers, once is not enough. Repetition, through presentation, subject matter, and style, makes several possible points. It draws attention not only to the mechanical nature of the photographic process, but also to the prominence of mass production in the modern world. It can emphasize an aesthetic observation, or stress the validity of a cultural phenomenon. With others, such as Bernd (b. 1931) and Hilla (b. 1934) BECHER, founder members of the New Topographics movement, their encyclopedic study of industrial forms—water towers, winding towers, presented in uniform blocks of nine— dispassionately highlights both similarities and differences, forcing us to read photography in a new way.

Likewise *Thomas RUFF* (b. 1958), a student of the Bechers, with his monumental deadpan portraits of the young, excises all the familiar reference points from his work. A portrait is supposed to tell us something about the subject, and photographers will use their full

Isms
While Modernism had focused on the medium, Conceptual Art dealt with the world of ideas, at times to the exclusion of any end product. Postmodernism threw its hands in the air, shrugged its shoulders, and said "anything goes as long as it's ironic."

bag of tricks to capture the telling expression or gesture that "brings out" the personality of the sitter. Ruff eschews all such fluff; his sitters are expressionless, staring blankly and blandly into the lens. No photographic cleverness of lighting or pose

1980s Keith Haring spray paints bright faceless figures, barking dogs, and radiant babies on subway walls, billboards, and buildings.

1984 "Trivial Pursuit" is introduced and has sales of $777 million in a year.

1988 Sinn Féin activists are no longer allowed to speak on British TV or radio, so their words are read out by actors.

intrudes upon the direct relationship between subject and viewer.

For *Keith ARNATT* (b. 1930), grand old man of 1960s Conceptualism, much of his photographic work reappraises the ordinary or discarded, repeatedly approaching the subject to create painterly images from mundanity. His "Rubbish Tip" series converts the jumbled detritus of modern living into luscious abstractions. For "The Sleep of Reason," he took the deformed rejects from a factory making small concrete figurines of dogs, and with touches of color he transformed them into objects of bathos. His subject matter is diverse, from old paint can lids with a

spectrum of accumulated splashes, to a poodle's-eye view of dog turds, closeup and revisioned as sculptural forms. The repetition reinforces the pleasure and multiplies the humor in his work.

Keith Arnatt burns his toast at breakfast time, but finds another use for it before the day is out. From the series "Pictures from a Rubbish Tip," 1988.

1982 At Wimbledon, Jimmy Connors wins the men's singles and Martina Navratilova wins the women's.

1984 Bob Geldof and Midge Ure persuade their friends to sing "Do They Know It's Christmas?"

1986 An accident at the USSR's Chernobyl nuclear power plant sends clouds of radioactive dust across Europe.

1982~1992

The First Casualty of War Is the Truth
Press control and video games

The lessons learned by the military during the Vietnam War (see page 102) *meant that photojournalists and film crews were going to have a much harder time of it in future conflicts. Control of the acquisition and dissemination of combat pictures, and friendly but firm censorship, was the new philosophy. The military became "helpful"; photographers were escorted to carefully selected "photo opportunities," and as long as they didn't try to cover anything "messy"—for instance, dead or mutilated people—they were cooperated with. All in the name of good taste and morale back home, you understand.*

American F-15 C fighters flying over burning Kuwaiti oilfields at the close of the Gulf War, 1991.

During the Falklands War in the early 1980s, the military's ace in the hole was distance. The renowned war photographer *Don McCullin* (b. 1935) was refused access to the war because of "a lack of room on the transport ships." As McCullin pointed out in a letter to *The Times* in London, the military found room for three million Mars bars but not for one of the country's leading photographers.

So the troops were able to work, rest, and play without unwelcome attention. News pictures were closely monitored, sanctioned, delayed, and presented by the authorities in a daily "news" briefing under the umbrella of "security." The press agency photographer Martin Cleaver sailed with the task force, and his pictures of troops

1988 The U.S. unveils the F-117A Nighthawk stealth bomber, which is invisible to radar.

1990 Saddam Hussein's Iraqi troops invade Kuwait. He is said to have at least five doubles to stand in for him in case of assassination attempts.

1992 Cormac McCarthy writes *All the Pretty Horses*, in which John Grady and Rawlins ruminate on the existence of God and end up in a Mexican jail.

Martin Cleaver's photo of HMS *Antelope* exploding in the Falklands, 1982.

enjoying their long cruise and landing in the Falklands managed to find their way back in a couple of days. However, his seminal image of the war, HMS *Antelope* exploding in a giant ball of flame, took three weeks to appear back in the U.K., due to "transport difficulties."

IN THE GULF

By the time of the Gulf War, things were much slicker. New weapon technology allowed much more exciting presentations by the military spokesmen. While the top brass were busy telling the gathered press that war was not a "Nintendo" game, the propaganda machine, with its nose-camera footage of "smart bombs" seeking out the right chimney to go down like some vengeful Santa Claus, was doing its best to create the illusion that it was. The war was depersonalized. We watched in awe as the "luckiest man in the world" drove his tiny car over the bridge just before the bomb hit the unluckiest man in the world; we gasped as the superintelligent cruise missiles checked their road maps before turning left and accidentally hitting a hospital; we had no sense that people were dying.

Only one image leaked out of the Gulf that captured the other side of the coin. Kenneth Jarecke's picture of the charred torso of an Iraqi soldier, killed in the turkey shoot of the fleeing convoy on the Basra road, was the first real depiction of suffering to reach the Western press. The public was no longer used to such unsanitized images and the British *Observer* newspaper received many complaints for publishing it.

> **IN THE FRAME**
>
> **Paul Harris**, *a freelance photographer whose work is frequently shown in London's* Daily Telegraph *and* Mail on Sunday, *spent much of the early 1990s covering the war in Bosnia and Croatia. Check out this collected work in his book* Cry Bosnia. *See also* **Susan Meiselas's** *book* Nicaragua, *reporting the 1981 war, and* **Jeff Wall's** *"Dead Troops Talk," shot in Afghanistan in 1986 (see page 133).*

1981 The unemployed are annoyed by British Cabinet member Norman Tebbit's assertion that they should "get on their bikes" to look for work.

1983 A new species of dinosaur is found in a Surrey claypit in southern England.

1986 America celebrates the 100th anniversary of the Statue of Liberty.

1980s~1990s

Lodging With the Family

The opinionated eye

Photographers getting their message across.

By the mid-1980s, the obituaries for black-and-white photography had yet to be written, with the work of Tony Ray Jones, Paul Hill, Chris Killip, and Chris Steele-Perkins occupying center stage. But "objectivity" as a central tenet was in a terminal coma. New photographers were coming onto the scene with "opinions," even prejudices, and they weren't afraid to show them.

Martin PARR's (b. 1952) book *The Last Resort* (1985) showed the rituals of people enjoying a day by the sea in the downmarket seaside town of New Brighton, England. His images—of a crowd struggling to get served in a fish and chip shop; families dining alfresco in seedy bus shelters surrounded by mounds of litter; and sunbathers in the shadow of a steamroller—offended and bemused traditionalists. In *The Cost of Living* (1990), he turned his eye on the middle classes. Parr is now considered one of Britain's foremost photographers, and his output has been prodigious over the last decade, with books, exhibitions, and TV programs. It seems that no Sunday supplement is complete without a Parr section.

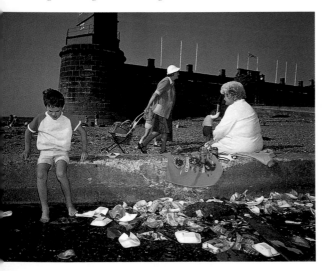

The seaside in New Brighton, from Martin Parr's *The Last Resort.*

1987 Author Jeffrey Archer wins a libel action against London's *Daily Star*, which claimed he paid a prostitute named Monica Coughlin.

1988 André Dubreuil's "spine" chair has a sweeping ladder of wrought iron following the line of the back.

1990 Dame Joan Sutherland gives her farewell performance at Covent Garden, London, singing in *Die Fledermaus* with Pavarotti.

Benetton

Throughout the 1990s, the Italian clothing company Benetton used documentary images to market their range of multicolored knitwear. "Serious" issues were appropriated for this advertising ploy, from a newborn baby and oil-covered cormorants to dying AIDS victims. If Benetton is "concerned" for the environment and humanity, then, by implication, so were their customers in the caring, sharing 1990s.

An untitled image from David Moore's "The Velvet Arena," 1994.

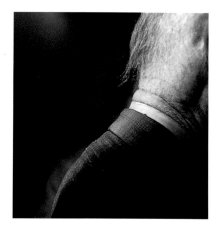

THATCHERISM

In the mid-1980s, it was very different. The Thatcher government had changed the industrial landscape. Heavy industry, coal, steel, and shipbuilding had all undergone radical change or "downsizing." The emphasis had moved to the service industries and "heritage," and Anna Fox addressed this issue in "Work Stations." What once was a steel mill or coal mine had been converted into a museum, with a few of the former employees reduced to reenacting their previous roles for tourists. In "I Can Help" and "Flogging a Dead Horse," Paul Reas shows the reaction of a mother with her children to a steely-eyed man following his Rottweiler through the crowd, and highlights his personal reaction to the growing social changes in the late 1980s.

The family, especially the working-class family, became a popular source of concern. David Moore brought an ironic gaze to a study of life in subsidized housing, as did Nick Waplington's "Living Room" in 1991. (Moore went on to produce "The Velvet Arena," a body of work that explored the hidden agendas of the book launch and the private view.) There is inevitably a measure of exploitation of the subject with all of this work. They become metaphors for the photographer's vision. This became problematic when, in the late 1990s, some of Martin Parr's early work was reappropriated for advertising images. In a trend, established by Benetton, that blurs the edges between documentary and advertising, the dignity of the original subjects becomes lost in the equation.

Box of tricks

One popular technique among the pros is to use flash as a "fill-in" light. Sophisticated flashguns allow the photographer to reduce the power output of the flash so that its light slightly "lifts" the foreground of the picture, heightening the color, highlighting texture, and emphasizing the content. This can be especially effective with portraits shot in front of a backdrop.

1975 Garry Trudeau wins a Pulitzer Prize for his controversial cartoon strip *Doonesbury*.

1981 In ice hockey, Doug Smail of the Winnipeg Jets scores a goal five seconds after the opening whistle in a match against the St. Louis Blues.

1982 Jean-Paul Gaultier gets into corsets with a collection premiering his corset dress.

1970~1990s

Sex, Drugs, & Rock'n'Roll
Soft porn to heroin chic

Those embryonic, subculture concerns of the Swinging 1960s had emerged full-blown into the light by the 1970s. The liberalization of attitudes toward depictions of sex and violence brought a "shock tactic" genre to fashion photography: automobile accidents and street crime scenes became the new locations and backdrops for it.

Knowing sophistication on *i-D* covers. Being hip was all about attitude rather than fashion.

H elmut NEWTON (b. 1920) and Chris von Wangenheim brought a nightmarish edge into the process of selling dreams. Newton created mininarratives edged with dark sexuality, throwing a gauntlet down to the growing feminist movement, and Von Wangenheim felt comfortable with shooting makeup ads showing a Rottweiler's jaw clamped around the wrist of the model.

By the 1980s a new aesthetic was developing, a less formal, less stylized vision, led by *Bruce WEBER* (b. 1946) and strongly influenced by the work of Nan Goldin (*see page 128*). Worlds apart from the De Meyerish origins of fashion, these images drew on the snapshot for their inspiration. Locations became the everyday—a couple kissing under a table, or a fight breaking out at a bar, became the new vehicle for selling boxer shorts. This convention continued into the 1990s, with new publications like *i-D* and *The Face*, as well as the existing

Über models

In the 1970s, the look of fashion changed, the big budgets fell away—if only temporarily—and new thinking, influenced by the rising feminist movement and the growing status of the models themselves, resulted in a new look. The models were ascendant and assertive, they could be glimpsed, paparazzi-style, coming out of nightclubs, and the clothes became almost secondary to the lifestyles of their wearers.

1986 Flamboyant pop star Boy George is convicted of possessing heroin.

1990 Ecstasy begins to become popular on the club scene as a stimulant drug that relaxes the inhibitions.

1996 Scottish movie *Trainspotting* shows a junkie disappearing down a toilet.

"heavies" such as *Vogue*, providing opportunities for Corinne Day, who photographed Kate Moss in a barren studio apartment; Elaine Constantine; Tillmans; and Teller (*see page 128*). Their influences were no longer the "great" fashion photographers of the past, but the cultural and sociological explorations of Cindy Sherman (*see page 127*), the compassion of *Mary Ellen MARK* (b. 1940), and the juxtapositions of the fantastic with realism by Japanese photographer *Noboyushi ARAKI* (b. 1940).

IN THE FRAME

By the mid-1960s, under the editorship of **Diana Vreeland**, *Vogue fashion shoots had become monumental. Like Victorian explorers, photographers traveled to the far corners of the globe. It became commonplace for $20,000 to be spent on a single spread in the early 1960s. In the early 1970s, the fashion gravy train hit the recession and, if not derailed, definitely skidded.*

Kate Moss poses in her undies; photo by Corinne Day, 1993, for *Vogue*.

DRAWING THE LINE

Fashion photography reflects the fickle nature of the fashion industry, drawing on trends and styles in mainstream art-photographic practice and changing course every few years. In recent decades, the boundaries between advertising and editorial have been breached, drawing fashion into a wider critical debate. As emotive topics such as "heroin chic," hard drugs as a form of dietary supplement, chain-smoking schoolgirl models, and rampant anorexia allow the tabloids and thus the public to peer into the glossy, closed circle of the fashion world, the documentary approach of the new photographers brings with it a measure of unwelcome scrutiny.

PHOTOGRAPHY ~ A CRASH COURSE **117**

1970 Robert Smithson creates his *Spiral Jetty*—a 15-foot-wide road spiraling out into the Great Salt Lake in Utah.

1981 Neville Brody becomes designer of *The Face* magazine and creates a look that is heavily influenced by punk.

1988 In Peter Greenaway's movie *Drowning by Numbers*, ever-decreasing numbers appear on the screen, giving viewers a clue of how long it still has to run.

1970s~1990s

Where's the Beef?

Robert Mapplethorpe

Senator Jesse Helms speaks his mind.

One of the defining moments of late-1980s America has to be when the right-wing Republican Jesse Helms got on his hind legs in the Senate to denounce Robert MAPPLETHORPE *(1946–89) and all his works. Waving the photographs aloft so that the TV audience could not see them clearly and thereby become instantly corrupted, Helms railed against the federal arts funding for Mapplethorpe's work, which, he said, depicted sadomasochism, the exploitation of children, and individuals engaged in indecent acts. Helms introduced legislation to prevent the National Endowment for the Arts from funding "obscene" work.*

The House of Representatives had already voted to reduce the federal arts grant by the amount it cost to mount a major exhibition of Mapplethorpe's work, and the Contemporary Arts Center in Cincinnati was prosecuted under local law for "criminal obscenity" after it exhibited his photographs.

Mapplethorpe's canon of work mirrors the changing face of American culture from the optimism and liberalities of the late 1960s to the Moral Majority backlash at the end of the 1980s. His vision was formed at Pratt Institute in New York where he studied fine art, turning to photography in 1972. His work from this period hints at the interests and concerns that were to become fully developed by the late 1970s: assemblages and

recontextualized "ready-mades" that adopted Dadaist and Surrealist methods but infused them with homoerotic symbolism.

Much of his work is characterized by the lingering gaze playing over the contours of, most frequently, the male body, and a formalistic documentation of the sado-masochistic practices of his circle of acquaintances. Even when the subject matter seems "innocent" by nature—as

Box of tricks

The white-faced look Mapplethorpe gets in many of his celebrity pictures can be achieved by putting a red filter over the lens. This increases the exposure of the skin tones, making them very dark on the negative so they print out correspondingly light.

1992 In Canada, five year-old Julius Rosenburg saves his sister from a black bear by growling at it and wins a Medal of Bravery.

1997 Dutchman Niek Vermeulen has collected 2,112 different airsickness bags, from 470 airlines.

1999 U.K. pop star Gary Glitter is convicted for downloading child pornography from the Internet.

Mapplethorpe, "Self-Portrait with Cane," 1988. The phallic symbolism of the cane could be a comment on his illness.

with the humble flower, for instance—it may become invested with a dark, often homoerotic sexuality. His most controversial work revolves around genitalia and sexual practices and is not for the fainthearted or anal-retentive; the unwary might be forgiven for thinking that they'd stumbled across a veterinary surgeon's training manual.

MORTALITY

In his final years, the specter of HIV introduced a new morbidity into Mapplethorpe's work. Where before there had been a joie-de-vivre in even the darkest subject matter, now the tone changed, with skull and death motifs predominating; in his self-portrait from 1988, shortly before his death from an AIDS-related disease, we are given a fleeting insight into a man staring into his own mortality.

Incidentally, a jury of lay people found the Contemporary Arts Center in Cincinnati not guilty of all charges: Robert Mapplethorpe was judged a "photographer of note" whose work had "artistic merit" and was therefore protected under the First Amendment. Jesse Helms' reaction was not recorded, but he continued to see himself as the scourge of photographers who deal with controversial issues (*see page 124*).

1979 Judy Chicago creates *The Dinner Party,* a large triangular table set for dinner and decorated with suggestive patterns.

1982 In Britain, 30,000 women form a ring around Greenham Common missile base in a protest against nuclear weapons.

1986 Nadine Vaujour learns to fly a helicopter and snatches her husband from prison.

1970s~1990s

Grrl Power
Portraits to politics

In hundreds of homes across the south of England, in albums or gilt frames, there are wedding and portrait photographs taken by Joanna Spence Associates, a commercial studio based in Hampstead, in London, in the late 1960s and early 1970s. These mark the first phase of the work of Jo SPENCE *(1934–92), a grounding in that hinterland between domestic and creative photography where, to the customer, the photographer replicates formulas they follow themselves, but with "better" cameras.*

Lesbian style
Claude Cahun's Surrealist work from the early 1920s became a beacon for the new wave of lesbian photographers of the 1980s. She had pioneered an androgynous, politicizing style, mirrored in literature by Radclyffe Hall's *Well of Loneliness.*

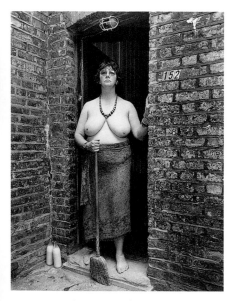

Jo Spence and Terry Dennett, "Colonization" from "Remolding Photo History," 1982.

As Spence's work and thinking consolidated into a political, feminist ideology, she took with her what she'd learned from this long interaction with the public perception of photography, and in 1974 she founded, with Terry Dennett, the Half Moon Gallery. They began an exploration of the politics of the family album and started a project called "Remolding Photo History," restaging classic images, with Spence herself adopting the female role and ridiculing traditional notions of the "feminine."

Jo Spence became one of the most respected practitioners and teachers of the 1980s, with numerous exhibitions and publications. She was diagnosed with breast cancer in 1983 and much of her later work concerned her relationship with the disease that eventually killed her. In 1983 Spence met *Rosy* MARTIN (b.1946)

1989 Advertising guru Barbara Kruger prints "I shop therefore I am" on shopping bags.

1992 Philippus Dierijck and Janet Münsch finally marry. They met in Stuttgart in 1944 and had promised to marry then, but were separated by the fighting and only found each other again 48 years later.

1996 Gillian Wearing films a group of male and female police officers keeping still and silent for an hour.

at a counseling course, and they worked together to develop "Phototherapy," a technique using the camera as a tool to reenact and resolve traumatic experiences. Martin's work has recently centered on themes of death: "Memento Mori Manifest" examines issues of bereavement, loss, and anger (*see page 9*).

Martin's photographs also featured in the influential "Stolen Glances: Lesbians Take Photographs" (1991), along with Della Grace's "Love Bites," a visual essay of the mating rituals of leather-clad, tutu-wearing young women, and "The Knight's Move," a series by *Tessa BOFFIN* (1960–93) on lesbian history and stereotyping.

Boffin's work "Angels Rebels" (1989) dealt with issues of lesbians and safe sex in the wake of the AIDS scares that swept the world in the mid-1980s. Boffin took her own life in 1993.

> **IN THE FRAME**
> *Many women photographers began to use visual autobiography in the 1980s and 1990s as a means of getting at universal truths.* **Nancy Honey**'s *photo essay "Woman to Woman" (1990) explores the elements that define her own sense of femininity, using stereotypical images of sexuality and gender that exemplify cultural attitudes toward the female.*

Tessa Boffin's "The Knight's Move."

1976 Vivienne Westwood's bondage trousers with joined-together-legs are virtually impossible to walk in.

1982 A book called *The G-Spot* is published and couples begin hunting anxiously.

1989 Denmark is the first country to legalize same-sex marriages, and two old gentlemen, Axel and Eigil, who've been a couple for over 40 years, are the first to take advantage.

1970s~1990s

New Narratives

Duane Michals

The still photograph is limited and ambiguous. Its meaning can be made clearer by the use of text or location. Text can anchor its meaning or make allusions to other meanings or issues. A picture shown in a gallery will emit a different message from the same image in a tabloid newspaper.

IN THE FRAME

*The painter **David Hockney** (b. 1937) started experimenting with multiple photographic prints in the 1980s. He attempted to picture a subject from many angles simultaneously, and produced large composite pictures he called "joiners," constructed from a hundred or more small prints. Other photographers who have used multiple print techniques are **Lucas Samaras** (b. 1936), who cuts and reassembles polaroids in disjointed panoramas, and **Joyce Neimanas**, with her reconstructed portraits.*

As "meaning" in photography took on a new importance from the 1960s onward, many photographers sought ways of going beyond the single "telling" image. Duane MICHALS (b. 1932) brought a unique vision to photography, and through his portrait work, but more significantly his sequences and use of accompanying text, has established his own poetic niche in photographic history. After completing his art-school training and military service in 1957, Michals worked as an assistant art director for *Dance* magazine in New York. The following year he was hired as a graphic artist in the advertising department of *Time*. It was

David Hockney, "An Evening at Christopher's," December 1982.

1991 President Bush's dog Millie's autobiography sells 400,000 copies. Seemingly she dictated it to First Lady Barbara Bush.

1992 Petra Kelly and Gert Bastian of the German Green Party are found dead in their bedroom from gunshot wounds.

1993 In the U.K. the Dyson Dual Cyclone vacuum cleaner is invented, eliminating the traditional vacuum cleaner bag.

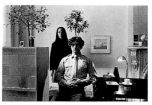

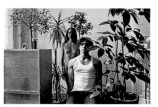

Duane Michals, "Paradise Regained," 1968. The story of the return to Eden raises questions of sexual politics and invites the viewer to contemplate them.

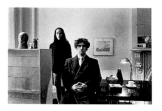

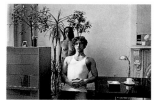

and deal with issues of love, human fragility, and innocence lost. Characters sometimes disappear without a trace at one point in the sequence, and questions are raised without being answered. See "Chance Meeting," "The Woman is Hurt by a Letter," "I Build

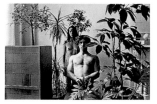

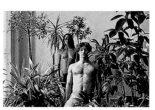

during a visit to the USSR that Michals first became interested in photography, producing street scenes and portraits, and he decided to try it out as a profession, working for *Vogue*, *Esquire*, and the *New York Times*.

His first major works were of deserted public places, which were later peopled with "actors" as he began his series of personal narratives in the mid-1960s. These demonstrate a simple mastery of technique and minimalistic storytelling; they have a surreal, dreamlike quality reminiscent of the paintings of Magritte,

a Pyramid," "Things are Queer," "The Bogeyman," and "The Young Girl's Dream." Hell, see them all.

Michals's first major exhibition was at MoMA in 1970, accompanied by his first publication, *Sequences*. He continued exhibiting, establishing an international reputation throughout the 1970s and 1980s, embellishing his sequences and portraits with text, and overworking his photographs with paint. An unassuming and gentle man, many (including me) believe Michals to be one of the great figures of the 20th century.

1983 20th Century-Fox pioneers product placement in movies whereby advertisers can have their products featuring prominently in movies, used by the stars.

1987 The Queen is not amused when Prince Edward persuades younger royals to take part in the undignified TV show "It's a Knockout."

1991 Sculptor Cornelia Parker produces *Cold Dark Matter: An Exploded View* out of fragments of a garden shed blown up by the British army.

1980s~1990s

Don't Touch That!
New materials, old taboos

"Degenerate art"
Witkin was denounced in the Senate by Jesse Helms and an exhibit, made out of ripped pages from Witkin's book, was displayed outside the Senate chamber by the Christian Action Network under the title "Degenerate Art."

In the early 1990s, when a small, seemingly innocuous picture was used to accompany an article in the Independent on Sunday, *announcing a forthcoming exhibition of the work of Joel-Peter WITKIN (b. 1939), sharp-eyed and sensitive readers complained by the bucket. Among the usual still-life ingredients of fruit and seafood, there appeared to be a human foot, and there, further back among the plums and cherries, the body of a dead baby. For many, this was their first introduction to the strange world of Witkin, and they found it difficult.*

Witkin referred to childhood experiences to explain his fascination with the body and body parts. Born to a poor immigrant family in New York, some of his earliest childhood experiences were of the smell of his grandmother's gangrenous leg, his mother's deep Catholicism, and a violent car crash that occurred outside their tenement building as Witkin was on his way to church with his mother and brother. A child's severed head rolled from the wreckage and landed at his feet. Jesse would say that's no excuse.

Witkin's images, luscious and complex in structure, contained body parts and severely disabled people, all used to an end that was not documentary (and therefore possibly "acceptable"), but more like an extravagant Dutch still-life or medieval tableau. My God! Were these art?

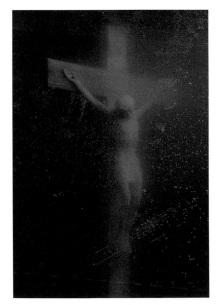

Andres Serrano, "Piss Christ," 1987.

1992 Sharon Stone makes men nervous about ice picks in *Basic Instinct.*

1996 H. Hurley of North Carolina grows a record-breaking green bean that is 4ft long.

1999 New York Mayor Rudolph Giuliani threatens to withdraw funding from the Brooklyn Museum of Art for showing the "Sensation" exhibition.

Joel-Peter Witkin, "Feast of Fools," New Mexico, 1990.

Forensics

For the forensic or scene-of-crime photographer, the dead and dissected become their everyday stock in trade. Encountering horror on a daily basis, they can only distance themselves from their subject matter by following strict guidelines and procedures. Forensic photography relies on these rules for its authority. A picture of a body presented as evidence is only reliable if we trust in the processes followed and the integrity of the photographer.

Well, yes, they were. Witkin, along with other artists, was exploring the boundaries of photographic practice. Bodily fluids and effusions, blood and guts all became fair game for consideration. *Andres SERRANO* (b. 1950) shared the proud distinction of being denounced by Jesse Helms for his work "Piss Christ," a beautiful image of a crucifix immersed in a yellow/orange liquid. Obviously it was the title that upset Helms and Co.—Serrano could have easily used Gatorade to get the visual effect. For Serrano, this work went to the heart of religious debate, questioning the merchandizing of iconography and taste.

GILBERT and *GEORGE* (b. 1942 and 1943) took semen and blood, creating giant prints from microscope images,

and made large pictures of themselves defecating. Probably not one for the dining-room wall. *Helen CHADWICK* (1953–96) created work by peeing in snow, then making casts of the results. As artists turned to the personal for their inspiration, their experiences, thoughts, and bodies all became relevant.

IN THE FRAME

Sue Fox *uses the dissecting table and the crematorium for her studio. Her camera explores the final moments of the physical and the incineration of the remains with concern and an aesthetic vision. Amidst the lick of the flames, horror and beauty become intertwined.*

1974 Evel Knievel earns $6 million for an abortive attempt to leap the Snake River Canyon in Idaho on his motorbike.

1981 After President Reagan is shot, his wife Nancy visits him in hospital and he jokes "Honey, I forgot to duck."

1992 France bans smoking in public places but French smokers completely ignore the ban.

1970s~1990s

Who the Hell Am I?

Notions of the self

Francesca Woodman was 22 when she died in 1981. She left behind more than 500 photographs, a body of work begun when she was barely a teenager. Yet the collection displays a unique maturity and insight, as layer by layer it explores who and what she was.

Portrait of the photographer as a self-conscious teenager.

Woodman's parents were both artists and academics, and she gained an early knowledge of the history of art and ideas. Sophisticated references to the surreal, to Hans Bellmer (*see page 91*) and Claude Cahun, suffuse her work, and the technique and style of Duane Michals (*see page 122*) is clearly influential. In many of her images Woodman turns the camera on herself, appearing and disappearing in a variety of guises and dusty surroundings; she fades in and out of the wall, the floor,

the fireplace. This symbolic journey, mapping her gradual understanding of herself and her womanhood, has been "discovered" and applauded in the 1990s,

Francesca Woodman, "Untitled, Providence, RI, 1975–1978."

1995 The first agony aunt in cyberspace is called "Emily."

1996 Astronaut Shannon Lucid spends 188 days in space, most of them on the space station Mir.

1998 Apple launch the iMac in a choice of acid colors—green, orange, pink, purple, and turquoise.

establishing the significance of her work. Her only publication in her lifetime, *Some Disordered Interior Geometries*, came out shortly before her suicide. Perhaps she had said what she wanted to.

While Francesca Woodman built up a picture of her self, *Cindy SHERMAN* (b. 1954) fragments her own life, exploring female stereotypes and representations, and tapping into a deep repository of cultural imagery in her "Untitled Film Stills" (1977–80). Drawing on a variety of Hollywood genres, she "reenacts" typical roles: the femme-fatale, the floozy, the housewife, the sex object, using the conventions of the publicity picture to question the portrayal of women in a male-dominated industry or society. Her photographs have none of

Cindy Sherman, "Untitled #123, 1983:" carefully staged and composed.

the intimacy of Woodman's work. Sherman is a blank canvas on which these other women are portrayed; you could pass her in the street.

From this series of 69 small black-and-white pictures, her work moved on to the large color prints. The "Disgust Pictures" (1986) use food, vomit, and other detritus, all gaudily lit and filtered; these were followed by "Sex Pictures" (1992), with anatomical dolls restructured into poses of sexual acts and submission, and "Horror Pictures" in 1995. All of these symbolized issues relating to eating disorders and the way the female is presented in myth and fairy tale. In the early 1990s, Sherman recreated the works of well-known European painters, still using herself as the model.

Long exposure

Many of Woodman's pictures used long or double exposure techniques to achieve her results. She placed the camera on a tripod for stability and used a long exposure—of several seconds—to allow static objects to be rendered normally. If the subject moved during the exposure, that section of the picture would have a blurred appearance.

Box of tricks

A normal exposure for a picture can be split in half, so that two exposures are made on the same negative. Anything that appears for only one of these exposures will appear semitransparent and ghostlike. Exposures can be divided into smaller fractions for greater control of this process.

1991 Average food prices in the U.S. are a dozen eggs for $1.10, a 1lb loaf of white bread for 70.5 cents, and chicken for 89 cents a pound.

1992 Hong Kong's 78-story Central Plaza becomes Asia's tallest building.

1993 There are local protests in London when the council will not allow Rachel Whiteread's plaster cast of a house to remain permanently on site.

1990s~today

Dear Diary

Confessional photography

In the "New World Order" of the 1980s and 1990s, it was now okay for the photographer to scorn the big issues, the "meta-narratives." As we have seen, there was a growing preoccupation with the "photographer": their lives, their friends, their families. The camera turned inward, revealing all, without apparent editorship.

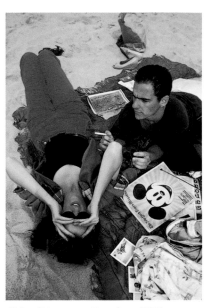

"C.Z. and Max on the Beach, Truro, Massachusetts" 1976, by Nan Goldin.

Webcams

As the Internet expands like the universe, the webcam allows us to interact with other users across a wide range of communication forms. The question is, who did the owner of the first webcam talk to?

In the late 1970s, *Nan GOLDIN* (b. 1953) started work on her "Ballad of Sexual Dependency," an ongoing project that documents the lives of her extended family. Seemingly casual snapshots in their approach, the images form a body of work wherein relationships, both casual and serious, blossom and fade, and the gradual onset of AIDS and addiction take their toll.

The photographs of *Juergen TELLER* (b. 1964) and *Wolfgang TILLMANS* (b. 1968) have certain similarities. Both men deal with youth culture and the emerging club scene of the 1980s. They straddle a hazy boundary between documentary and fashion, where images of their friends and acquaintances have no stylistic distance from their pictures of supermodels and celebrities. Both work extensively for the new wave of style magazines that emerged out of the muddle of the early 1980s.

By this time, new technology was allowing for a more intimate, more voyeuristic and immediate exploration of an individual's life. Jennifer Ringley *(see page 137)*, a student at Dickinson College in Pennsylvania, set up a web camera in her dormitory room that transmitted an

1994 In *The Bell Curve*, U.S. sociologists stir up controversy by claiming that IQs are immutable.

1996 Alan Nash and Shirleen Whitehead win the World Toe Wrestling Championships in Staffordshire, England.

1999 Indiscreet English diarist and MP Alan Clark dies in the U.K. Among the revelations in his diaries were descriptions of Margaret Thatcher's flirting techniques.

image on to the Internet every three minutes, allowing at first a small band of devotees to observe, for whatever reason, the details of her occupancy. Like Nixon "forgetting" the tapes in the Oval office, Ringley would not be consciously posing for all these images.

This got popular, and became at times quite "interactive," as she demonstrated her lack of inhibitions. In fact, Jennicam was an Internet milestone. At a time when others seemed to feel that live Internet pictures of the center of Dayton were somehow interesting, this young woman tapped into a deep voyeuristic need, perfectly in tune with the new technology, and spawned countless imitations.

It was only a matter of time before baring your soul on the Internet led to the fine-art community finding something more graphic to bare. Natacha Merritt, a 22-year-old San Francisco-based artist, downloads her multigenderal sexual

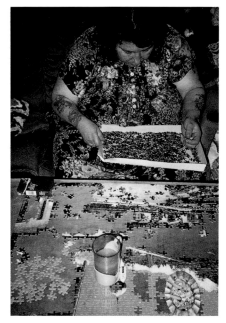

Richard Billingham, "Untitled," 1995; his mother concentrates on a jigsaw.

IN THE FRAME

While other photographers were gatecrashing the lives of the working class and taking up squatters' rights in their spare rooms, **Richard Billingham** *(b. 1971) photographed his own dysfunctional family. In "Ray's a Laugh," in the mid-1990s (by which time a wacky, post-modern title for your artwork was obligatory—this being one of the better ones), Billingham brought a more intimate vision to a family life far removed from the traditional model. This whole trend of family-oriented work was given official validation by the "Who's Looking at the Family?" exhibition at the Barbican, in London, in 1994.*

adventures via her bedside webcam to a worldwide but discerning audience. When any word entered into a search engine is only one page away from blundering into a hardcore porn site, her work can be seen as an ironic comment on the Worldwide Web.

1991 Christo arranges giant umbrellas across the countryside: blue in Japan and yellow in California.

1993 In Italy, the new highway code bans kissing while driving a car.

1994 Filmmaker Derek Jarman dies of AIDS. One of his last creations is a sculptural ecology garden in the shadow of the Dungeness power plant.

1990s

The Found Photograph
A touch of recycling

Joachim Schmid, "Ansel Adams, Yosemite National Park, 1956," from *Masterpieces of Photography*.

When Man Ray and Berenice Abbot "discovered" the work of Atget (see page 46) or Lee Friedlander printed the work of Bellocq (see page 49), they brought forgotten bodies of work back into the public domain. Just like an archaeologist uncovering an ancient tomb, these treasures were deemed "important" and worthy. Photography is often mapped by studying the great "Masters," but too much time spent on this pursuit can end up giving you vertigo.

Guerrilla Girls
As advertising execs have increasingly delved into the annals of art and photography for their inspirations, photographers have begun to redress the balance, taking advertising techniques and turning the message on its head. The Guerilla Girls, a group of feminist activists, attack the representation of women within advertising and fine art by appropriating well-known images and giving them an ironic spin.

Sherry Levine reevaluates this process by rephotographing the images of the "Masters" and signing the prints with her own name. The result is, after all, "her" photograph. In "The Chases School," Christian Boltanski took images of Jewish schoolchildren from a 1931 photograph and reconstructed them into a poignant altar of memory. More and more photographers began to use the vast untapped archive of domestic and largely anonymous photography to question values and to create new narratives.

Joachim Schmid, a prime mover of the "found image" oeuvre, collected discarded and lost photographs in "Pictures from the Street," leaving the audience to ponder the meanings of the pictures and to construct a history. In his series "Masterpieces of Photography" from the mid-1990s, Schmid trawled his vast archive of domestic pictures and collated those that had uncanny resemblances to the work of the "Masters," here an Ansel Adams (*see page 98*), here an August

1995 John Grisham's *The Rainmaker*, Michael Crichton's *The Lost World*, and Danielle Steel's *Five Days in Paris* are the best-selling books in the U.S.

1996 U.K. Agricultural minister John Gummer feeds his young daughter Cordelia a hamburger to try and convince the media that there's nothing wrong with British beef.

1999 The Northern Ireland peace agreement is implemented and all parties sit together in self-government in the province.

Hazel Stokes meets Matthew Kelly, Alvin Stardust, Stratford Johns, Simon Williams, Lionel Blair, and Julian Clary, in Stephen Bull's series "Meeting Hazel Stokes."

Sander (*see page 76*). With them, he explores the miasmic process that elevates some work to "Great" status.

Patrick McCoy found some damaged negatives on the streets of Belfast, and the prints from these scratched and holed pictures carried inescapable associations with the site of their discovery. Stephanie Bolt is working on an ongoing project called "The Browns," with assistant Liz Kent, which involves contacting every A. Brown in the British telephone directories and asking them to send a picture of themselves to form a living archive of late 20th-century life. Artist and lecturer Stephen Bull, in his series "Meeting Hazel Stokes," exhibited pictures of the eponymous Hazel, a theater usherette in Canterbury, who for 20 years had been pictured alongside the stars

IN THE FRAME
Barbara Kruger *takes the techniques of the graphic arts, promoting notions of beauty, fashion, and heterosexuality, and recontextualizes them in her own style to raise questions of stereotyping and gender bias.*

performing there, showing the ebb and flow of celebrity status over the decades from over-the-hill pop stars to forgotten faces caught in aspic, the only constant being Hazel, gently aging.

Found photography readdresses the hierarchy of photography, and rebalances the fulcrum between the few "Masters" at the apex and the vast collective of amateur pictures.

An image from the "Browns" archive.

131

1982 A spectacular set showing Los Angeles in the year 2019 is created for the movie *Blade Runner*.

1992 There is a gun battle in Ruby Ridge, Idaho, after a federal marshal shoots a Labrador retriever and the 14-year-old owner shoots the marshal.

1993 A suicidal Tamil militant straps explosives to his body and kills Sri Lankan president Premadasa and 23 others.

1980s~1990s

Constructions and Manipulations
Goldsworthy, Colvin, Wall

"Cattle Skull, Bad Lands, South Dakota" by Arthur Rothstein, 1936.

As we've seen, photographers can get themselves into hot water for fiddling with "reality"—Arthur Rothstein (see page 75) was accused of moving a cow's skull, Don McCullin (see page 112) of rearranging the contents of a dead Vietcong soldier's wallet, and Robert Capa of possibly staging the dying Spanish soldier (see page 82)—as if there is some fixed reality out there that is only "true" from one specific conjunction at one specific time. As a theory, this is about as much use as a wet cigarette, but people get very passionate about "truth."

Some artists wisely sidestep this debate altogether, preferring instead to construct their own "realities" for the camera. This process can vary in content and intent, and raises questions as to the nature of the "art object." *Andy Goldsworthy* (b. 1956) creates "environmental" sculptures, using natural materials, such as wood, stone, sand, and snow and sculpting new forms from them in their native surroundings. Many of these pieces are in remote locations, and the only awareness of them that we can have is through photography. So these pieces function on two levels: the original, out there somewhere, and the carefully taken picture. Other photographers, like Boyd Webb, with his disturbing eroticism; Arthur Tress ("Fish Tank Sonata"); and Calum Colvin, construct pieces in the studio or on location specifically for the camera.

Andy Goldsworthy sculpture on Kangaroo Island, Australia, 1992.

1994 The *Lion King* opens with Disney animation and songs by Elton John and Tim Rice.

1998 Viagra is licensed in the U.S. for use by droopy men and a black market springs up in countries where it is not officially available.

1999 Steve McQueen wins the Turner Prize with his Buster Keaton-inspired video of a building falling on a man.

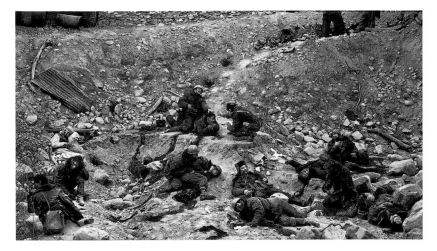

Jeff Wall, "Dead Troops Talk (A Vision after an ambush of a Red Army Patrol, Afghanistan, 1986)."

IN THE FRAME

American photographer **David Levinthal** *uses toy soldiers, cowboys, models, and dolls, shot in a "shallow focus" way, to comment on the myth of the American West, objects of desire, or, in his more recent work, the rise of the Nazis. His technique is to create small studio "sets," miniature tableaux, where his fuzzy creations act out stereotypical scenes like "B" movie stills.*

Colvin's early work used specially-built sets, overpainted so that from the camera's angle, the tangle of subject matter formulated itself into the likeness of a face, in a revisiting of trompe l'oeil. His more recent work, "Pseudologica Fantastica" (1996), uses digital manipulation where liquidized seaside snapshots weave their way through a Dalíesque landscape.

The artist Jeff Wall uses digital manipulation and montage to create vast, back-lit tableaus that resemble epic war paintings of the 19th century. In "Dead Troops Talk" (1992), an allegory of the end of the Cold War, Russian troops lie in a frozen battleground, and the corpses taunt and gesture at each other, reflecting the futility of dying simply to achieve the annexation of Afghanistan.

Exile

The photographer Mari Mahr, born in Santiago, Chile, produces work that deals with exile and memory. Her constructed images combine a South American sense of the symbolic power of objects with a European cultural tradition.

1992 Eric Clapton writes the song "Tears in Heaven" after his young son falls from the window of a skyscraper.

1994 Tiger Woods wins the U.S. Amateur Golf Championships, the youngest man and the first black person to do so.

1995 France resumes nuclear testing in the South Pacific and a T-shirt on sale in Australia lists "ten reasons to hate the French."

1980s~1990s
Quiet Angers
Black and Asian artists

As we have seen, photography is an effective medium for highlighting injustice and prejudice. Issues surrounding racism in particular have been raised by photographers challenging the white norm.

When the Afro-British photographer Rotomi Fani-Kayode creates an image of a black man holding a tribal mask, he taps into centuries of custom and tradition, alludes to a more recent history of slavery and racism, and explores notions of the exotic. But when Mapplethorpe (*see page 118*) photographs a similar subject, all of these cultural references are lost and the obsession is with the surface, the subject objectified.

In the late 1970s and 1980s, British black and Asian artists, including Chila Burman, Zarina Bhimji, Joy Gregory, and David A. Bailey, began to address the misconceptions created back in the 19th century, when British, French, and German photographers traveled through their countries' colonies, bringing back pictures that portrayed the native populations as primitive and

Disability
For David Hevey, it is how the media represents people with disabilities that informs his work. In "Striking Poses" (1990), his role is to empower his subjects so that they control their own image, reacting against the "invisibility" or patronization of the disabled in mainstream photography.

Images from David A. Bailey's "Family Album." It's breakfast-time and the clock's minute hand moves slowly around.

1996 It is reported that 25% of American children live below the poverty line.

1997 British yachtsman Tony Bullimore capsizes in the South Atlantic Ocean and spends five days trapped underneath his boat before he is rescued.

1999 Cherie Blair, wife of British Prime Minister Tony Blair, announces she is expecting her fourth child at the age of 45.

exotic (*see page 69*). These images were suffused with notions of colonial superiority, their subjects submissive.

This, alongside a vision of "New Europe" in a modern multiethnic society, led a number of photographers to begin using the medium to reassess these relationships. Major exhibitions, such as "Reflections of the Black Experience" (1986) and "The Other Story" at London's Hayward Gallery in 1989, and "Asian Artists in Post War Britain," brought this work to a wider audience. This included David A. Bailey's 1987 series entitled "Family Album," and Ingrid Pollard's "Pastoral Interludes," where she positions herself in quintessentially "English" landscapes, contesting the common vision that ethnicity is an inner-city phenomenon.

We see a similar idea explored with Yinka Shonibares' "Diary of a Victorian Dandy," where he photographs himself in recreated Victorian tableaus. Keith Piper's multimedia work deals with notions of the black body

IN THE FRAME
Sunil Gupta, *born in Delhi in 1953, has been a leading curator and spokesperson for black and gay visual arts in Britain since the early 1980s. His own work, such as "Pretended Family Relationships" (1988), deals with relationship issues and cultural divides.*

as a site of colonial power, or as an object of fear and fantasy. In "Surveillance: Tagging the Other" (1992), he addresses questions of how the power structures of the state, the police, and the judiciary react to black presence in a manner that remains extraordinarily topical.

Screaming tabloid headlines are juxtaposed with a background montage of family snapshots.

1985 In *Back to the Future*, Michael J. Fox has to go back to the 1950s to arrange for his parents to meet so that he can exist.

1994 Renzo Piano's Kansai International Airport in Osaka, Japan, is the second man-made structure that can be seen from space, the Great Wall of China being the first.

1996 Two new computer games, Quake and Doom, have participants running through dark passages dodging attacks from aliens; more and more levels of difficulty can be added so they are almost impossible to master.

1980s ~ the future
Well, Scan Me!
The digital revolution

In the early 1980s, the respected National Geographic *magazine got into a pickle for allegedly tinkering with the pyramids, modifying their alignment to fit the front cover. We'd better get used to this. At the end of the century, just as photography is finally finding its feet and becoming accepted as both a documentary and creative medium, digital manipulation and the death of the negative threaten to undermine this.*

The digital age offers unbridled opportunities for photographers with a point to make. Goodness Mr. Clinton, your nose seems to be growing ….

The authority of photography as a documentary practice diminishes as images become genetically modified. Major picture agencies are considering rubber-stamping the back of pictures to attest to their "authenticity." Photography is evolving, doing what it has always done, moving with the times.

The naiveté of the expression "the camera never lies," lodged deep in the collective unconscious of the viewer, is gradually being eroded as manipulated images become more commonplace. The trust in the ethical position of the photographer and the picture editor becomes more problematic. While it might seem innocuous to add a few more spots to illustrate a princess's chickenpox, it is slightly more sinister to manipulate pictures that influence a murder trial or political campaign.

The explosive growth of the Internet during the late 1990s has brought new and radical changes to the way we communicate and interact with each other.

1997 The Internet crashes on April 25 and becomes unusable for up to 8 hours.

1999 Following the success of the book *Men Are from Mars, Women Are from Venus*, a new book claims that cats are from Mars and dogs are from Venus.

2051 "Beam me up, Scotty" becomes a reality when scientist Alvar Crown transports himself from his lab into his kitchen.

Scanners and digital cameras herald the slow demise of traditional film, possibly relegating the black-and-white print to a fine-art or, worse still, "crafts" backwater. The family album slowly gives way to the family website where you can bore the whole world with your vacation videos. Scientists are walking around with implants that interact with computer systems: currently they only do difficult things like open the door or turn the lights on, but as progress marches onward, this will change. Interacting with the computerized world will allow us to think our commands, and like modern fighter-pilot helmets, our minds will give us a dual vision, one of the physical world around us and one of some inexhaustible Internet link—telepathy by machine.

Spending the night in DC taking care of the kitties :)

What a long day! Driving and driving...and next to NYC @ 2am and back, then taping, then the wrap party. I'm tired already! :)

Jennifer Ringley lives a very public life (*see page 129*). If you want to watch a new image of her every three minutes, go to her Jennicam website.

Favoritism

There's always a danger in these situations of being forced to choose one's favorite photographer, as if such a thing could exist. Photographs should do something—preferably that thing the photographer set out to achieve. If they make you laugh or cry, if they make you angry or sad, if they make you see things afresh, get off your butt, and shout about something, then photographs are worthwhile and valuable. Oh, all right then: Duane Michals.

AND IN THE END

So there we have it. Well, yes and no. In the space available, we have swept through the centuries and more recent decades of salient points in the development of photography, highlighting and glimpsing major movements, ideas, and practitioners, observing the growth of the medium from its stumbling beginnings to a practice that permeates modern life. Advertising and commercial photography, the recording of sports, of theater, of disease, births, and weddings—all deserve a place in the panoply, if only for criticism. There is no doubt that photography is an important aspect of all our lives, recording, informing, and misleading us. But at the end of all this, it's important to remember that photography can also just be fun.

Glossary

A glossary of common photography jargon. Impress the guy in your local processing lab and bore your friends.

ABSTRACT IMAGE

Or "What's that supposed to be?", a hopefully conscious decision to render the subject matter, by viewpoint or technique, into an image that relies on shape, form, light, and texture for its effect.

ALBUMEN PRINTS

Prints made by coating paper with an egg white and salt solution and sensitized with silver nitrate. This left a surplus of egg yolks, so many early photographers made a mean omelette.

APERTURE

The circular hole in a photographic lens that controls the amount of light hitting the film.

AUTOCHROME

Not the shiny stuff plastered onto 1950s automobiles, but an early color process using red, blue, and green dyed potato starch grains coated onto a glass plate.

AUTOFOCUS

Way of not having to think too much about your image.

AVANT-GARDE

Used to describe Art that is ahead of its time or just plain weird. French for vanguard.

BROMIDE PRINTS

Standard black-and-white photographic paper coated with silver bromide in gelatin. Not to be confused with "taking a bromide," a Victorian way of calming down.

CALOTYPE

Talbot's term for his process. From the Greek for "beautiful picture," which seems a little self-congratulatory.

CANDID

Originally meaning that the photographer was unobserved by the subject; nowadays widely used as a replacement for the word "smutty."

COLLAGE

Assembling bits and pieces to make a picture. From the French *coller* (to glue).

COLLODION

A mixture of guncotton (created by dissolving cotton in nitric acid) in a solution of ether and alcohol, used originally for wound dressings. This sticky solution solved the problem of bonding the emulsion to a glass plate. Handling these materials in the field would probably account for a lot of out-of-focus pictures.

CONTACT PRINTS

Prints made by shining light through a negative pressed onto photographic paper. This gives a print the same size as the negative. The photographer may show you a sheet of contact prints from which you can choose which to print at a larger size.

DAGUERREOTYPE

Louis Daguerre's self-immortalization.

Fox Talbot was encouraged to rename his process the Talbotype but modesty forbade it.

DEPTH OF FIELD

A term describing what is in acceptably sharp focus within a photograph. Small apertures and wide-angle lenses usually give the greatest depth of field.

DEVELOPMENT

A cocktail of chemicals that turn exposed silver halides within a photographic emulsion into black metallic silver.

DIGITAL IMAGING

Image-creation and manipulation by electronic means, as opposed to a chemical process. Widely believed by traditionalists to herald the "death" of photography.

EMULSION

The coating on photographic film and paper that contains the light-sensitive material. Not to be confused with the paint of the same name—this won't work.

EXPOSURE

The control of light, film speed, shutter speed, and aperture to give the desired result on the film. Or, if you're sitting out in the wind and rain waiting for that "perfect" landscape picture, the thing you die of.

F-NUMBER

A highly confusing set of numbers on the lens that denote the size of the aperture. The higher the number the smaller the aperture. Each successive f-number doubles or halves the amount of light transmitted. Also known as f-stop to add to the confusion.

FILM SPEED

This denotes how quickly film reacts to light. Currently there is an international system that all manufacturers adhere to, using the ISO standard. An ISO 100 film is twice as sensitive to light as ISO 50, and half the sensitivity of ISO 200, etc.

FILTER

Glass or acetate sheets, usually fitting over the camera lens, used to alter color or contrast on the image. A wide range of "special effects" filters are also available, to achieve triumphs of style over content; use with extreme caution.

FIXING

A chemical process, using sodium thiosulfate after development, which renders the exposed areas insensitive to light and permanent. Not to be confused with "fixing up," which an over-exposure to ether and alcohol can lead to.

FLASHPOWDER

Magnesium powder ignited by a spark. Unpredictable and occasionally dangerous. Not recommended in driving rain. Superseded by the flashbulb.

FOCUSING

A mechanism that allows the photographer to select the amount of the image that is acceptably sharp, assuming sobriety.

FREELANCE PHOTOGRAPHER

Out of work.

GUM BICHROMATE

A process that uses paper coated with gum arabic and potassium bichromate, giving a soft, painterly feel to the finished image. The acceptable face of photography to the fine-art brigade.

MONTAGE

The joining together of several images to form one picture, often for no good reason.

NEGATIVE

An intermediate stage in the photographic process where light areas appear dark and vice versa. Also an attitude of mind regarding new ideas.

ORTHOCHROMATIC

Photographic film and paper that is insensitive to red light which allows it to be handled in a darkroom.

PANCHROMATIC

Black-and-white photographic film and paper that is sensitive to all colors of the spectrum, reproducing a correct range of black, white, and gray.

PHOTOGRAPHY

General term coined by Sir John Herschel. From the Greek *photos* meaning light, and *graphos* meaning writing. Led to generations of early photographers talking about "painting with light." To be avoided.

PLATE CAMERA

Camera using sheets of film as opposed to rolls. Also known as Studio, Monorail, Field, Technical, or heavy cameras.

POSITIVE

A photographic image that renders color, or tones of black, white, and gray, as they were in the original subject.

SHOOT

Part of the macho nomenclature of photography, interchangeable with "take," "capture," and "grab."

SHUTTER

A mechanism that controls the length of time that the image is exposed onto the film. Most cameras have a focal plane

shutter, a window in front of the film. More sophisticated and generally more expensive systems have a shutter built into the lens. Shutter speeds are in fractions of a second, each adjacent number doubling or halving the exposure time.

SILVER HALIDES

Originally used by Daguerre and Talbot and still used today, silver halides are compounds of silver that react to light (i.e. silver chloride, silver bromide, and silver iodide). This is why it's all so expensive.

SLR

Single lens reflex camera. Uses an internal mirror to reflect the image into the viewfinder. What you see is what you get.

SOLARIZATION

Reinvented by each generation of trainees, solarization is the time-honored practice of accidentally switching the white light on in the darkroom during exposure. This gives a combined negative/positive feel to the print. Only Man Ray would have the gall to name this process after himself.

STRAIGHT PHOTOGRAPHY

Apparently unmanipulated photography, where all decisions about the picture have been made prior to pressing the shutter, with no evident camera trickery or darkroom "magic." Has potential to be extremely self-righteous.

TWIN LENS REFLEX CAMERA

Uses two matched lenses, positioned one above the other, one for viewing and focusing and the other for exposing the film. Introduces notion of "parallax error" or "cutting head off subject," because one lens "sees" a slightly different image from the other.

VIEWFINDER

Device for checking that you're photographing what you think you are. Comes in a variety of forms, from a simple wire frame on early box cameras to sophisticated through-the-lens mechanisms on modern machines.

VIEWPOINT

Normally used to describe the relative positions of camera and subject. Of equal importance, though, is having a point of view about your subject.

Index

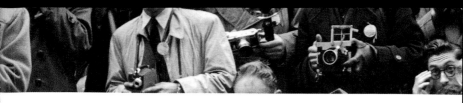

PHOTOGRAPHIC CREDITS

The publishers are grateful to the following for permission to reproduce copyright material. Every effort has been made to trace copyright holders, and the publishers would be pleased to be informed of any errors or omissions for correction in future editions.

Copyright belongs to the respective photographers, and additionally:

AKG, London: 19b, 38, 40b, 41t, 44/45, 45, 53t, 70 (National Galerie, Berlin), 71

The Art Archive, London: 13, 33

© **Eddie Adams/Associated Press:** 102

© **Keith Arnatt:** 111

© **David A. Bailey:** 134/135

© **Herbert Bayer, DACS, 2000:** 66

© **Bernd and Hilla Becher, courtesy Sonnabend Gallery, New York:** 110

© **Hans Bellmer, ADAGP, Paris and DACS, London, 2000:** 91

© **Richard Billingham, courtesy Anthony Reynolds Gallery, London:** 129

© **Tessa Boffin Estate:** 121

Courtesy Stephanie Bolt and Liz Kent: 131

© **Manuel Alvarez Bravo, Copocan:** 92

The Bridgeman Art Library, London: 12 (Caves of Lascaux, Dordogne),15b, 28b, 37t (The Science Museum, London), 42, 53b (National Museum of Photography, Film and Television, Bradford)

Courtesy Stephen Bull: 131t

© **Martin Cleaver/The Press Association:** 113

Corbis, London: 15r (David Lees), 31 (Sheufler Coll), 34, 68b (E.O. Hoppe), 74, 98 (© Ansel Adams Publishing Rights Trust)

Corbis/Hulton-Deutsch: 2 + 77 (Bert Hardy), 39b, 54

Corbis/Bettmann: 25, 30, 32/33, 38t, 48, 49, 52b, 52t, 67

Corinne Day © **Vogue/Condé Nast Publications Ltd.:** 117

© **Harold and Esther Edgerton Foundation, courtesy of Palm Press Inc., Concord:** 100

© **William Eggleston/Art and Commerce Anthology Inc:** 108

© **Alfred Eisenstaedt** © **Life Magazine–Time Inc./Katz:** 72

Courtesy the Fricke and Schmid Collection: 130.

© **Fay Godwin/Collections:** 99

© **John Heartfield, DACS, 2000:** 71

© **David Hockney:** 122

© **Hannah Höch, DACS, 2000:** 70

Hulton Getty, London: 21, 24/25, 27, 51 (Evening Standard), 59t, (Kurt Hutton), 73l, 73r, 83 (© Bert Hardy), 87 (© Don McCullin),105t (Gordon Anthony), 105b (R.McPhedran), 112

© **Nan Goldin Studio, New York:** 128

© **Andy Goldsworthy Studio:** 132b

© **André Kertész** © **Ministère de la Culture, France:** 80/81

Library of Congress: 75

Magnum, London: 10 & 84/85 (© Elliott Erwitt/ Magnum), 10 & 88 (© Bruce Gilden /Magnum), 11& 97 (©Abbas/Magnum), 78 &79 (© Henri Cartier-Bresson/Magnum), 82b (© Robert Capa/Magnum), 83t, 85 (© Eve Arnold/Magnum), 89 (© Bruce Davidson/Magnum), 94/95 (© Ian Berry/Magnum), 114 (© Martin Parr/Magnum)

© **The Man Ray Trust/ADAGP, Paris and DACS, London, 2000:** 59

© **1988 The Estate of Robert Mapplethorpe, courtesy Art and Commerce Anthology Inc.:** 119

© **Rosy Martin:** 9

© **David Moore:** 115

© **Duane Michals, courtesy Pace/MacGill Gallery, New York:** 123

© **El Lissitsky, DACS, 2000:** 64

Irving Penn © **British Vogue/Condé Nast Publications Ltd.:** 104

© **Albert Renger-Patzch Archiv/Ann u.Jurgen Wilde, Köln/DACS, 2000:** 60

Rex Features, London: 106, 107

© **Alexander Rodchenko, DACS, 2000:** 65

© **Sebastião Selgado/Network:** 93

© **August Sander, DACS, 2000:** 76

© **Andres Serrano, courtesy Paula Cooper Gallery, New York:** 124

© **Courtesy Cindy Sherman and Metro Pictures:** 127

© **Raghubir Singh/Colorific!:** 96

© **Jo Spence Archive, London 1982:** 120

© **Joel Sternfeld, courtesy Pace/MacGill Gallery, New York:** 109

© **Paul Strand** © **1971 Aperture Foundation Inc., Paul Strand Archive:** 62

© **Nick Ut/Associated Press:** 103

© **Jeff Wall (D. Pincus coll, Philadelphia):** 133

© **Peter-Joel Witkin, courtesy Pace/MacGill Gallery, New York:** 123

© **Courtesy Betty and George Woodman, New York:** 126